HONISTER SLATE MINE

Alastair Cameron | Liz Withey

AMBERLEY

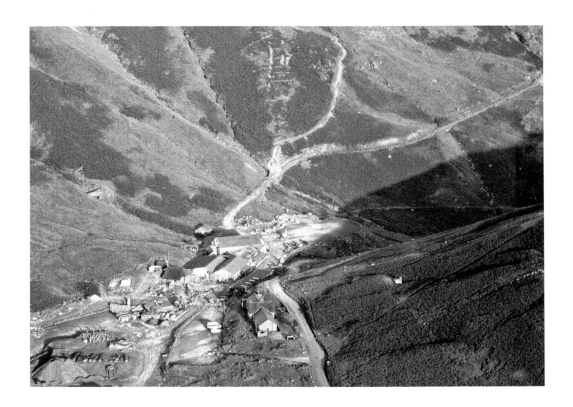

First published 2018

Amberley Publishing
The Hill, Stroud
Gloucestershire, GL5 4EP

www.amberleybooks.com

British Library Cataloguing in Publication Data.
A catalogue record for this book is available from the British Library.

ISBN 978 1 4456 7199 4 (print)
ISBN 978 1 4456 7200 7 (ebook)

Origination by Amberley Publishing.
Printed in Great Britain.

Contents

Introduction

Slate working is one of the Lake District's most traditional and historic industries and, along with fell-farming and other rural trades, was sufficient to sustain and provide a meagre income for the valley communities for a long period of time.

As with all other rural trades, slate working started on a small and very basic scale; then, as the centuries progressed, the quality and 'usefulness' of the material was recognised. Slate started to become the preferred method for roofing prestigious houses and other buildings throughout the land. As this continued an expanding industry developed, producing a product that is still in demand today.

For many centuries slate has been 'won' from the Honister Mine, located deep within Honister Crag, and also from surrounding mines and quarries in the Honister area. This book briefly describes the development of the industry at Honister, through the craft era and on into the industrial age.

During these times the method of mining, the transport of material down from the mines and the shipment away to other parts of the country tasked the lease holders to the extreme. They found it necessary to adopt the most novel and innovative methods for transporting 'finished' slates down from the working sites within the crag to the lower ground. Eventually the site of manufacture of the final product was moved from the dark chambers within the crag down to purpose-built workshops at Honister Hause.

During the second half of the nineteenth century, with the improvements to the road system in Cumberland, manufactured slates could be transported by road down to Braithwaite station yard to make use of the newly opened Penrith to Cockermouth railway.

During the first half of the twentieth century the mining sites continued to be developed. Both world wars had the inevitable effect on halting development but the sites recovered in both cases. Then, in the 1980s, things started to change.

In 1985 the lease for Honister was taken over by McAlpines of Penrhyn, North Wales. This major producer of slate products was clearly wanting to obtain a source of attractive Lake District slate. The plan was to work slate by open-cast techniques on the surface of Fleetwith, thereby creating a 'super-quarry' of significant proportions. But the results of exploratory core-drilling into the fell just below the summit were not satisfactory. Honister was much more suited to being worked by deep mining, and on a much smaller scale. Consequently, the site was closed completely within five years and the lease was put up for sale.

This book is not just concerned with the past history of the site. The Honister lease was eventually purchased by a local Borrowdale-born man whose forebears had been slate quarrymen. The work of Mark Weir, a person of extraordinary ability, vision, drive and determination, overcame immense obstacles and returned the derelict site to a thriving, viable industry, albeit on a much smaller scale.

Mark re-opened the mine and set up a new company under the name of the Honister Slate Mine Ltd. Production of slate from Honister's Kimberley vein started again. Mark also had a vision of how disused parts of the mine could come alive again as visitor attractions, either by guiding interested groups through parts of the mine no longer being worked or by encouraging outdoor activities on prepared routes on the face of Honister Crag. This has now developed into a significant, unique tourist attraction that runs parallel with the working of slate extracted from deep within the crag.

Mark Weir died in a helicopter accident on 8 March 2011; however, what could have been closure for the Honister Slate Mine Ltd was averted by his close family stepping in, taking over operations and continuing to develop his concept. This has continued up to the present day and is most likely to continue with future generations.

The two authors of this book have felt that, as well as the history of the site, recent developments, events and successes at Honister should be reflected in depth in their publication.

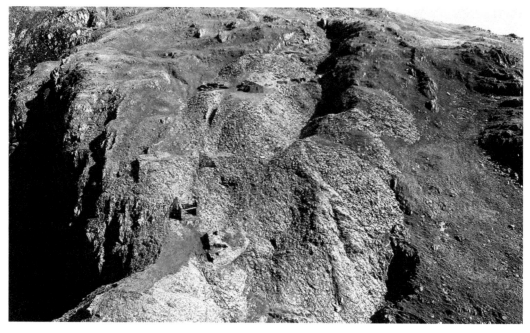

During the late nineteenth century and the first half of the twentieth century the high ground just below the crest of the hillside at Yew Crag had developed into an almost completely isolated living and working community, with production and manufacturing facilities adjacent to living accommodation for the slate quarrymen working at the various quarries in that area. One contemporary writer of the time reported that the area was similar in many respects of the remote crofting communities in the Western Isles of Scotland. (Mark Simpson)

Setting the Scene

The tract of mountain country that runs north from Great Gable and Brandreth terminates abruptly on the high moorland known as Fleetwith. From Fleetwith Pike, the summit of the fell, the land falls away steeply on three sides to the lower ground below; on the south side is the valley of Warnscale, to the east is the Buttermere Valley and to the north the impressive facade of Honister Crag falls, almost vertically, to Gatescarthdale.

Honister Crag is 1,000 feet high and, since Victorian times, has been a point of spectacular interest to those taking the road along Gatescarthdale. Tourists would stop and gaze up in wonder at the near-vertical screes and rock buttresses above. Even by today's standards the scene is grand and spectacular.

Few tourists who travelled up the Gatescarthdale Road in these former times would be conscious of the fact that Honister Crag was a major industrial site. The mining of slate on the crag probably started shortly after the Norman Conquest and today there are remains of industrial activity from all eras, including right up to the twentieth century.

For the fell-walker or rock climber the crag itself offers little or no potential for their sport, and the reason for this will be obvious soon. However, Fleetwith Pike is a summit frequently visited by fell-walkers for an afternoon's walk. The route from the car park at the Hause is a pleasant stroll and takes the walker past some of the earliest slate outcrop sites that were worked at Honister. Those with an inquisitive mind will soon wonder about the location of the slate, where it lies, how it came to be present here and how it has been worked over the years.

It is now generally accepted that deposits of volcanic slate rock in the Lake District, from which slate products are manufactured, frequently occur in bands. This is very much the case on either side of Gatesgarthdale, on both Honister and Yew Crags.

These bands of slate were laid down from lava beds and ash flows that were produced as a result of extensive volcanic activity in the Ordovician Period of geological time, 450 million years ago.

Much more recently glacial action during the ice ages has scoured out deep valleys, such as Gatescarthdale, removing parts of the slate bands. However, within Honister Crag and Yew Crag the slate bands remain intact. They were protected from the destruction of glacial action and in much more recent times have been mined for many hundreds of years.

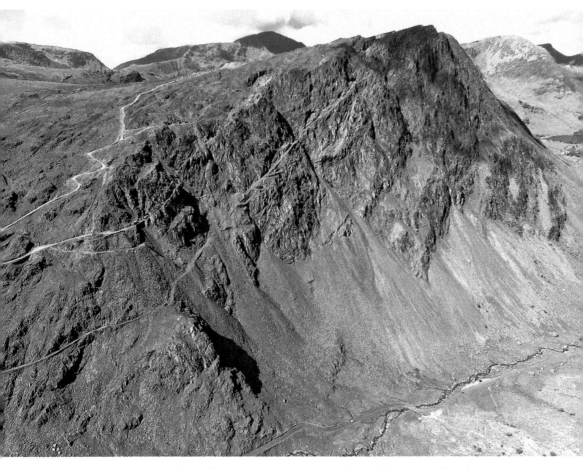

Honister Crag forms a significant feature, dwarfing cars on the road below. Within the crag are two separate slate mines and the roadways leading to the entrances can be clearly seen.

Beyond are the north-west Lake District fells, and to the right is part of Buttermere Lake. (Mark Simpson)

Three bands of slates have been worked commercially. The 'newest' of the slate bands, the Kimberley band, has been worked on Honister and Yew Crags and produces a dark green slate. Slate of the Honister band is a paler green/grey colour, and the oldest band, the Quay Foot band, which has been worked to a much lesser extent, produces slate with a blue tinge.

At the present time both the Kimberley and Honister slate bands are being worked at Honister Crag but no working of slate has taken place on the Yew Crag side of the pass since September 1960, when the Yew Crag mines and quarries were closed down.

Yew Crag is best viewed by those climbing the track from the Hause to Fleetwith Pike. Slate has been worked here extensively, mainly from underground mines, but some surface working of slate has taken place where the slate bands outcrop on the shoulder of the fell above the crag.

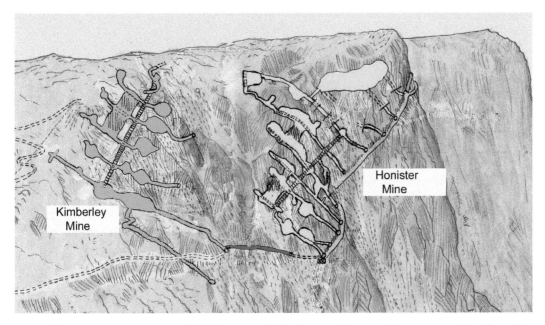

This basic representation of the location of the slate workings within Honister Crag has often been used to give an understanding of the history and method of operation of the slate mines.

Approximate locations of slate bands on Honister and Yew Crags

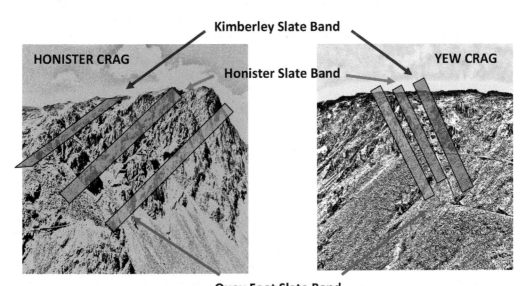

Three bands of volcanic slate – the Kimberley Band, Honister Band and Quay Foot Band – rise up in a north-westerly direction within the crags on either side of Honister Pass. These bands are well defined and in many places the boundary between the slate and non-slate rock is quite distinctive.

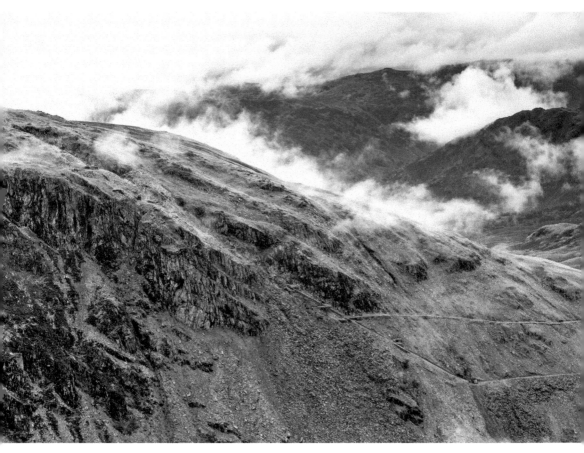

From Black Star on the lip of Honister Crag the view across to Yew Crag is extremely impressive. The remains of the open slate quarries can be seen high on the shoulder of the fell. The route of the lower tramway and upper road leading from the Hause to the Yew Crag slate mine workings is also very clear.

Early History

We are told from experts in historic buildings that slate was used in this area during the Roman occupation and that some clear evidence survives. However, from our point of view the actual start of the fledgling industry of slate quarrying and mining, and the associated production of slate products, didn't really occur then. Rather, it took place shortly after the Norman Conquest.

The invaders from France and the Flemish countries were very familiar with slate and its properties seeing as slate had been mined for several centuries in a number of locations, including the Ardennes. As the Normans started to become settled in the area they brought with them not only their technology and style of architecture but also their general way of life.

By the thirteenth century we find that several of the major monastic houses in what is now Cumbria were roofed in slate and possibly contained other slate features as well. St Mary's Abbey, founded in 1127 (Furness Abbey), held significant lands in Borrowdale and there can be little doubt that dwellings constructed there by the Abbey would have made use of slate from the outcrops on Fleetwith.

The culture of communities in the Lake District at this time was extremely basic. Small dwellings in the valleys had to be totally self-supporting and were almost completely isolated, linked only by rough pony-tracks. Few of the valley folk had any idea of routes across the fells to neighbouring valleys. The higher fell land was a dangerous and unknown area to them, and this was also an area where law enforcement rarely took place.

One group that did venture into the high fell area was the slate quarrymen. At Honister the outcrop workings on Fleetwith and above Yew Crag were where those from the Borrowdale area obtained their raw material. Manufacturing of their slate products took place up there as well and the shipment of the finished product down to customers was almost always by pack-pony. Life continued in this way for almost 300 years.

It is very likely that these skilled men only worked slate from time to time, when slates were required for their own property or an 'order' for slates was received from a neighbour. They would then go up to their sites and probably remained there until the required quantity had been produced. Once complete, and once the slate had been despatched to the customer, they would return to their valley home and take up their normal work, which was most likely a basic form of farming.

As the decades went by, and the demand for slate slowly increased, the areas where outcrop working had taken place started to expand into the open-cast quarries that remain today. The slate was worked downwards following the steep angle of the slate beds.

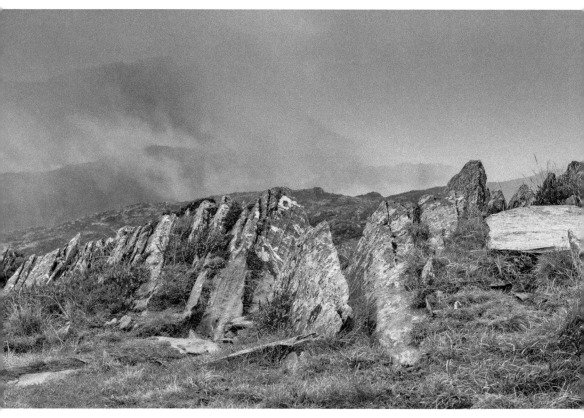

The earliest workings of slate at Honister were by simple surface quarrying techniques at a point where the slate beds outcropped to the surface. This small outcrop area was almost certainly worked in this way. No doubt if the ground in front was cleared, there would be extensive evidence here of the manufacturing of roofing slates.

At the same time it became obvious that the slate beds also outcropped on the crag face, no doubt after one or two intrepid slate-workers decided to go over the rim of the crag to take a look! As a result the upper part of the crag became the next site of extraction.

Working ledges were established on incredibly steep mountainsides and two very steep pony tracks were constructed from the sites up to the rim of the crag. Today much of the shape of the steep area of the crag, where the Honister Crag Railway upper winding drum is situated, was created entirely by several hundred years of slate workers' activity.

Although there is no actual evidence, it is generally felt that the technique of mining slate rather than quarrying was first introduced by, or was as a result of, the arrival of Tyrolean miners in Cumberland in the 1560s at the request of Queen Elizabeth I. These men were almost certainly the most skilled miners in the world at that time and one of the techniques they introduced was that of driving tunnels into hillsides to intersect mineral veins underground. Undoubtedly this technique would soon be learnt by slate workers and, on the steep rock faces at Honister, would have been adopted quickly.

Extraction of the raw material now moved down from the fellsides above to the upper part of the crag face. In total five separate 'levels' (tunnels) were driven into the mountainside in this area and slate rock mined where the tunnels intersected the light-green slate band. Slates were manufactured in small 'riving sheds' close to the entrances of the tunnels and were transported up to the rim of the crag by pack pony.

Extraction on these high parts of the crag continued in this fashion for over 200 years, until the commissioning of the inclined railway up the face of the crag took place in the 1890s.

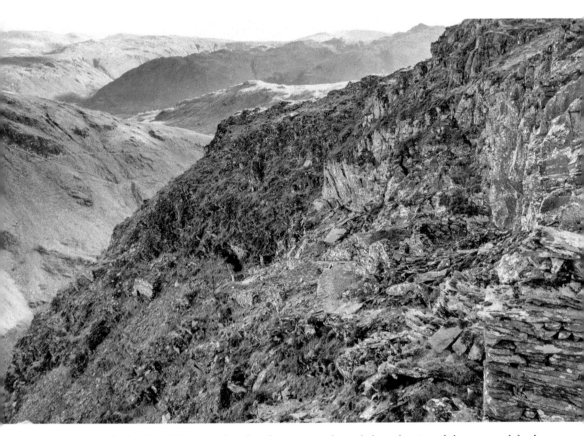

The slate beds of the Honister slate band outcropped just below the rim of the crag and further extensive open-cast working took place at this location for several hundred years. Most of the steep ground in this photograph was created artificially by slate extraction. Slates were also manufactured in riving sheds in various parts of this area and were then loaded into panniers on pack ponies to be carried up to the rim of the crag, and eventually on over the fells in 'pack trains' to the Cumberland coast.

In much more recent times the upper part of the Honister Crag tramway was laid through the area. The tramway, which ran up the entire crag, passed through the Ash Crag tunnel, which emerged towards the lower left-hand side of the photograph. It then ran for the final length up to the drum house, the ruins of which can also be seen towards the right. In present-day times the trackbed has been restored and is now the route of the Via Ferrata ascent of Honister Crag, allowing those who climb the crag in this way to view one of the oldest slate production sites in the area.

Transport Away

In November 1833 the lease for slate working at Honister, Yew Crag and Dubs quarries changed hands. The previous leaseholders had quit in 1830 but the estate had found it difficult to attract a suitable operator quickly. It was a difficult site to work and a transport system was virtually non-existent. They were very fortunate that the lease was eventually taken up by Mr Samuel Wright, a local and very competent quarryman.

By this time the open quarry sites along the rim of the crag had expanded considerably. Underground working, just beneath these sites, had also become extensive. There were clearly significant reserves of slate rock so attention now turned to improving the difficult task of conveying slates from these working sites to the ports on the Cumberland coast for transport away.

For hundreds of years pack ponies had been the main means of transport. Pack-horse trains were a frequent sight on the well-established paths across the fells. Many colourful stories were told about the exploits of the 'pack-men', which often involved the smuggling of contraband. It quickly became clear to the new lease holder that pack pony transport all the way to the coast had had its day; improving transport was a key issue that required solving quickly.

By the middle years of the nineteenth century the road system within the area had developed significantly. It was now possible for a horse and cart to gain easy access to Gatesgarth Farm and also to continue some way up the road towards Honister Hause. Access could also be made into Warnscale, to the south of the head of Buttermere. There was clearly potential to use these two 'road-heads' as loading points for finished slates. However, pack ponies would still be required to take slates down from the quarry sites into Warnscale and slates produced from workings on Honister Crag and Yew Crag had to be taken down to the Honister road by hand-sledge. But, from the road-heads onwards, horses and carts could carry their fragile loads to the coast with much less likelihood of breakage.

This was only the start. Sam Wright also constructed an amazing series of graded track-ways from the higher workings on Honister Crag and from Dubs Quarry down to Warnscale. Today these have been studied and mapped by industrial archaeologists, and they are known as 'Sam Wright's Roads'.

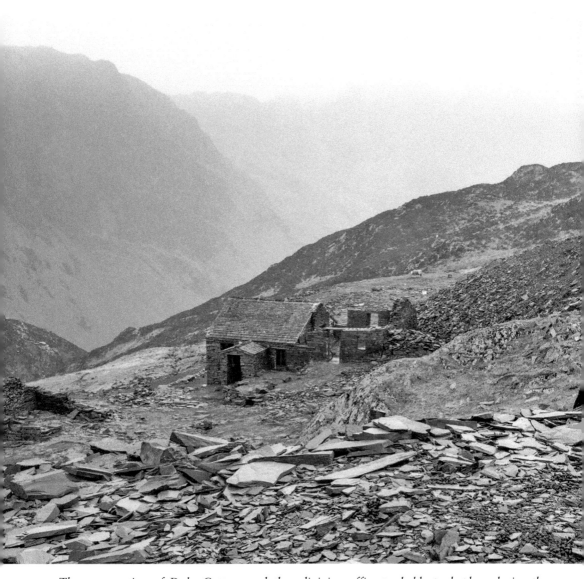

The construction of Dubs Cottage and the adjoining office probably took place during the early years of the nineteenth century. It almost certainly replaced an earlier dwelling, reputedly the home of Moses Rigg, a leader of pack-pony trains and a legendary smuggler of contraband from the coast. Later the actual cottage was the site from which Sam Wright administered the operation of all the slate mines and quarries within his lease. After the Dubs slate workings closed down in 1932, the cottage remained intact. More recently it was used by a variety of outdoor enthusiasts for overnight accommodation. In 2012, the cottage was sub-leased to the Mountain Bothies Association (MBA), a well-respected organisation dedicated to the upkeep of such remote dwellings.

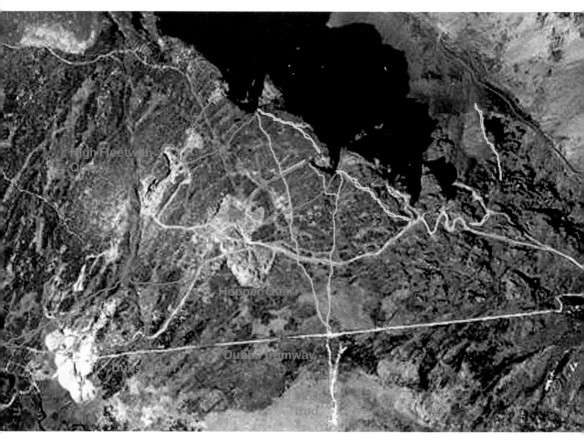

The pack-horse routes known as Sam Wright's Roads fan out over Fleetwith, linking the slate working sites with valley roads. They were extremely well constructed routes and would have greatly assisted in the transportation of slate products. During the period from November 2005 to April 2006 a complete archaeological survey was carried out of the roads that were still visible. The routes marked in red linked the working sites on the crag face with the valley at Warnscale. The orange routes linked the sites with the route that ran over the fells to the Cumberland coast, known locally as 'Moses Trod', and the routes marked in yellow are the return routes for the sledge-men carrying their empty sledges back up to the lip of the crag for re-loading.

In 1865 the railway from Penrith to Cockermouth was opened for goods traffic. This created even more possibilities for the transport of product away from Honister. Braithwaite station, on the new line, had good loading facilities and, for the time being, horses and carts were able to make the journey down to Braithwaite with ease.

Sam Wright would not be able to see any further development. In 1872 he retired, having spent almost forty years of his life operating the Honister site.

New proprietors took control in 1878 and took on the name the Buttermere Green Slate Company, a name which was retained for over 100 years.

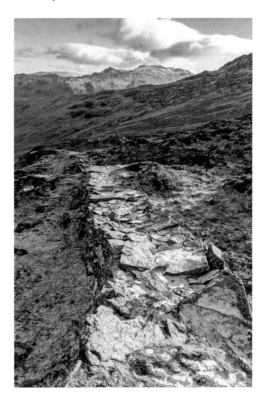

Part of the route of a Sam Wright Road still retains its surface paving. Another section of the road that crossed a marshy depression was elevated on bridge abutments to allow easier passage.

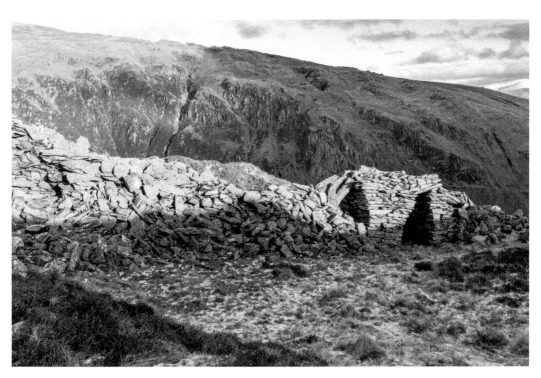

The Railway Age Arrives

By 1879 the new lease owners had become established. This meant that work could finally start on the construction of a narrow gauge rail system linking the slate-mining sites with Honister Hause. The first to be completed was the rail link from the Yew Crag workings.

These workings are extensive in surface area and, today, consist of surface outcrop trials, open quarries and underground slate mines. The first working of slate was probably during the 1600s. By the middle years of the nineteenth century the open Yew Crag quarries were extensive and some slate mining on the Kimberley vein was beginning to take place. A long counterbalanced incline was constructed in 1880 to serve the enlarging open workings but, when these quarries were being phased out in preference to underground extraction, major reconstruction of the incline was necessary.

Two years later work also started on the Honister Crag Railway. The first section of the railway was planned to run from the Hause to the foot of Honister Crag along an embankment. When this section was finally completed this was nicknamed the Monkey Shelf by the rather sceptical workforce.

At the foot of the crag the route then turned upwards, with the inclined railway being constructed right up the face of the crag to a terminus on the skyline at the head of Ash Gill. The scheme took fifteen years to construct and, amazingly, when complete it all worked. It operated fully for thirty years, after which it was abandoned in sections.

In 1890 another ambitious scheme was proposed to link the mines and quarries at Dubs with the Hause. Again, this involved the construction of a narrow gauge tramway from Dubs up to the summit of the fell and then steeply down the other side to the Hause. The route surveyed was almost completely in a straight line and was commissioned within a year. The initial section of the tramway was operated by a team of horses, which took trucks of slates from Dubs up to the highest point. From there a counterbalanced system lowered trucks gently down to the stockyard at the Hause, controlled from the high point by a winding drum fitted with a reliable braking system.

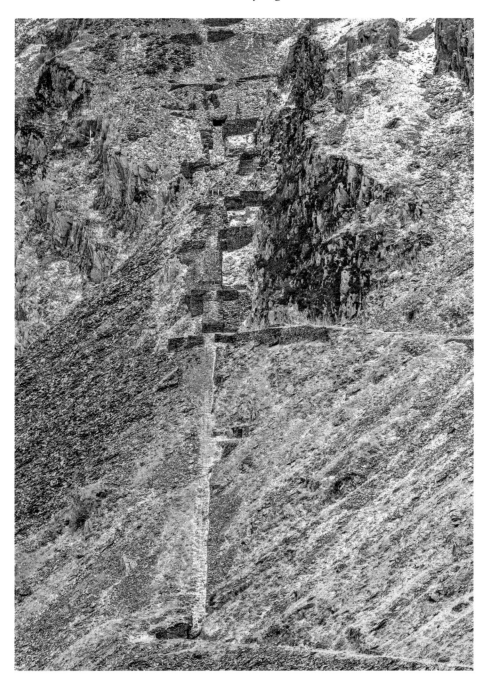

This amazing structure, built in 1880, is the long counterbalanced incline that transported finished slates down from the manufacturing sites to the unloading point at the incline foot. From here, horse-drawn trucks initially, and the Company's steam wagon ultimately, carried them on to the workshops at the Hause. In the 1940s the layout of the incline was altered significantly; the winding drum and upper section were abandoned and the incline was extended downwards to a new terminus, which can be seen in this photograph.

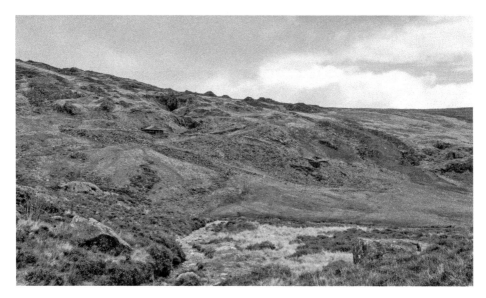

The long tramway running from the Dubs slate workings over the shoulder of Fleetwith and down to Honister Hause was one of the longest in the district. The route of this section of the tramway lies across the fellside to the right of the photograph. Horses operated the tramway as far as the Drum House at the highest point. They were stabled on the Dubs side.

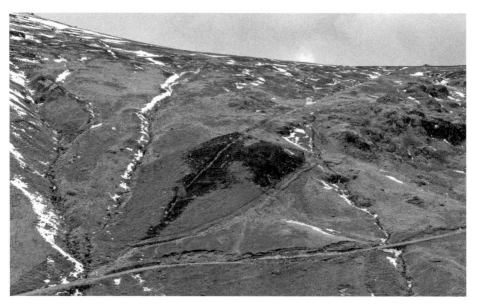

The final part of the journey for slate from Dubs Quarry involved a steep descent down the lower slopes of Grey Knotts on a counterbalanced incline system, which led directly to the stockyard at the Hause. The incline operated until 1932 when it was finally closed down. During the 1960s a misguided and unprofessional attempt was made by local authorities to 'landscape' the trackbed of the incline, which has left scars on the hillside that are visible for miles.

Finally, as if that wasn't enough, the Company started to plan the last missing link – a tramway linking Honister with the Penrith to Cockermouth railway at Braithwaite. This scheme would involve driving a railway tunnel through Dale Head to emerge at the head of the Newlands Valley. The route would pass down Newlands and eventually end at Braithwaite station yard. Work started on the tunnel in 1888, despite strong opposition from the landowner in Newlands. The Honister Company persevered and arranged for Lord Leconfield to put pressure on the landowner to change his mind. Sadly, this was unsuccessful and work on the tunnel had to be stopped before 'breaking out' into the Newlands Valley. As a result, the project had to be abandoned.

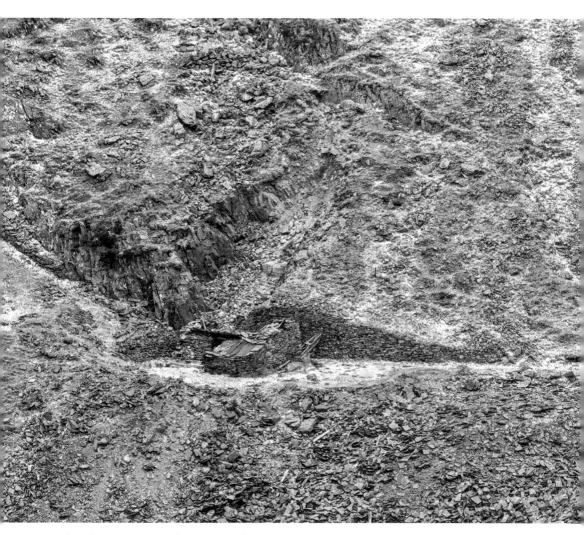

There has been much dispute over the years as to the actual location of the portal for the Dale Head tunnel; many believe it was at the location shown in this photograph, but others disagree. More recently this location was the site of the electric winder that powered the modified Yew Crag incline. Behind the ruined buildings, a tunnel runs into the hill for approximately 85 meters.

The Railway up the Crag

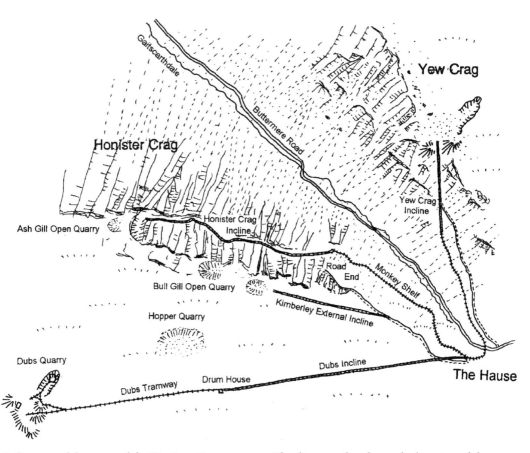

A diagram of the route of the Honister Crag tramway. The diagram also shows the location of the Yew Crag and Dubs tramways, all terminating at Honister Hause.

The Honister Crag tramway was an engineering triumph of its time. The route followed almost exactly the line of the Honister Slate Band that exists within the crag face. In all, eighteen mine tunnels exit from separate underground workings within the slate band at locations adjacent to the railway. Once commissioned the transport of manufactured slates became relatively simple for the first time; stock could be removed easily from the mine itself directly down the face of the crag to the stockyard at the Hause.

The tramway was constructed in three sections. The first, from the base of the crag up to a deep gully known as Bull Gill, was started in 1883 and was completed two years later. At the top of this section, right on the edge of Bull Gill, a drum-house was built and a winding-drum installed to operate this first section of the incline.

Once completed, the first section was immediately put to good use and slate miners who worked within the lower part of the crag were able to load trucks with manufactured slates at the entrances to their mines and have them transported safely down the crag to the stockyard at the Hause. The new system was clearly going to be a huge benefit to Honister and within two years plans were made to start construction of the middle section of the railway.

The middle section was completed in 1895. When commissioned it meant that about two thirds of the length of the slate band was now served by railway transport.

Decisions then had to be made. It was clear that slate mining had been partially phased out high on the crag and it might not be cost effective to continue the railway all the way to the top, as first planned. However, the reason for this was mainly because of the difficulty of transporting slates from this high location down to the stockyard.

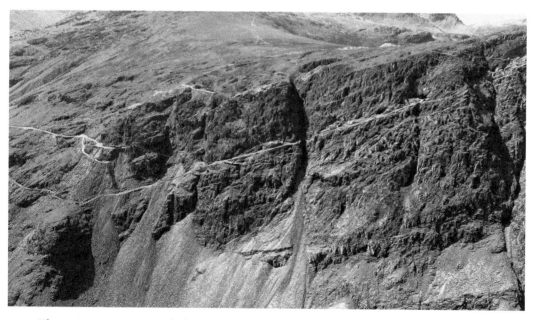

The major engineering of the construction of the Honister Crag tramway is very evident in this photograph. Even by today's standards this engineering project would be considered to be a significant undertaking. It took a total of twelve years to complete and was in use for over twenty-five years. (Mark Simpson)

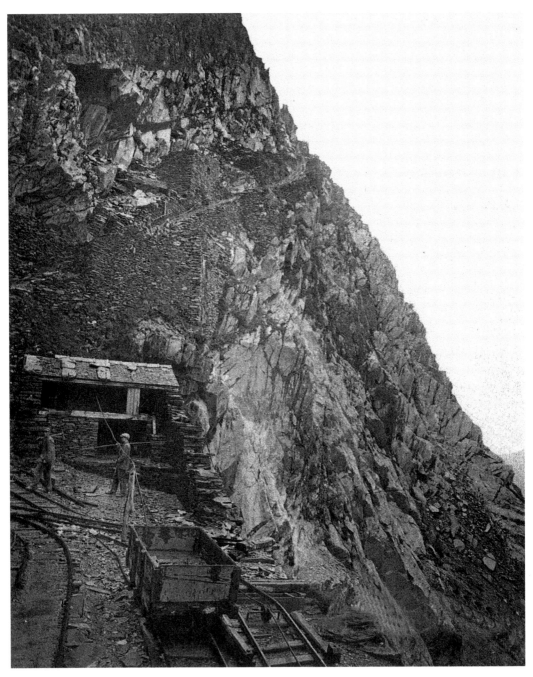

At the head of the first section of the incline, the Bull Gill drum house, containing the winding drum, was sited right on the edge of the crag face. To the right of the drum house the braking mechanism, which was operated by the brakeman, controlled the movement of the carriers on the incline below. Beyond, the centre section of the incline can be seen with the steep masonry structures that acted as revetment walls supporting the steep trackbeds of this higher section.

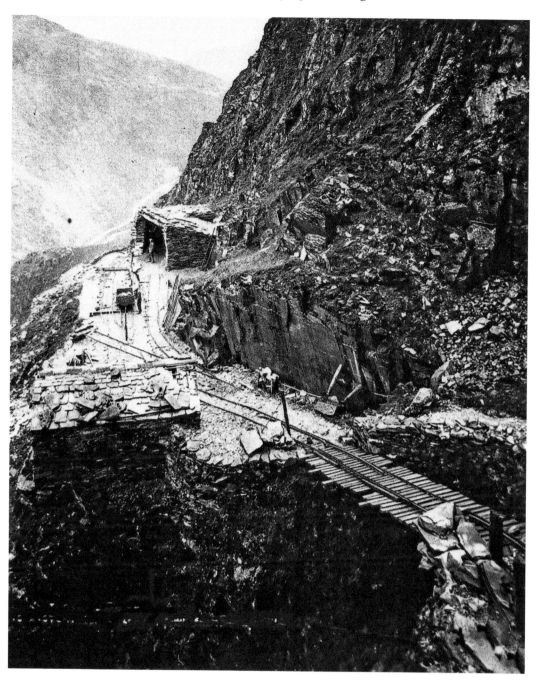

A view looking down on the Bull Gill drum house from above. To the far right the former causeway that originally carried the rail track across Bull Gill is still in place but abandoned. The acute curve on the causeway often resulted in slate trucks becoming derailed. The causeway was replaced by the steep wooden bridge in the foreground that spanned Bull Gill at a much gentler angle, which significantly improved the operation of the incline.

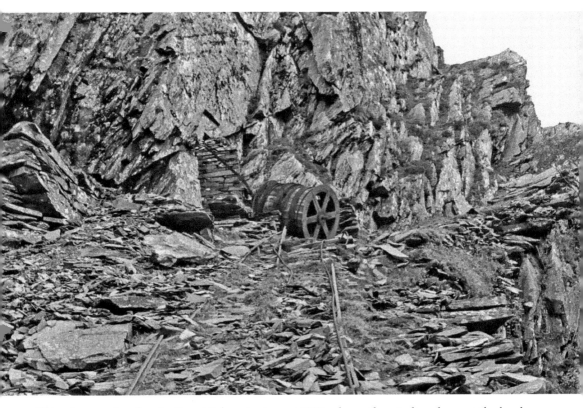

This photograph, taken by Peter Holmes in August 1978, shows the winding drum at the head of the Nag Back section of the tramway, lying in a very precarious position. Today no sign of the drum remains. A few weeks after this photograph was taken a team returned with ropes to secure the drum, but found it had vanished. It was probably a victim of the winter storms.

The Honister slate band had been extremely productive up there during previous centuries and there was no reason to think that this would alter. Consequently, plans were drawn up to take the incline right up to the Ash Gill Quarry on the rim of the crag.

The route involved driving a tunnel through Ash Crag and constructing raised trackbeds to carry the railway over the ancient open workings at Ash Gill. Today, little remains of this highest section of the system.

Aerial Flights

The old incline railway up the face of the crag had been a great development. When it was installed it had improved the operation of the site immensely, but it was slow, required constant maintenance as a result of Honister's extreme weather and was only designed to carry finished product, referred to as 'made slates'. This meant that all manufacture of roofing slates had to take place within chambers high up in the crag.

As the facilities at the Hause expanded it became clear that it would be better to move the production of slates from the crag down to purpose-built workshops at the Hause. To achieve this it would be necessary to transport large blocks down from the crag. The big question was how to do it!

The answer lay many miles south, above the old mining village of Coniston. Here, in 1902, the owners of the Old Man Quarries had installed an aerial ropeway from the Scald Cop workings, their highest on Coniston Old Man, to a road-head much lower down the mountain at Stubthwaite. This was to be the first of five aerial 'flights' installed on the mountain, which were designed to carry made slates and slate block in specially designed trays dangling from aerial cables.

This system must have appealed greatly to the operators of the Honister workings. Aerial flights were clearly the answer, although they realised that the extreme steepness of the crag, and the fact that part of the face was slightly overhanging, meant that ropeways could not be used directly off the crag face. Instead, an underground inclined tramway within the mountain would be necessary as the first stage of the journey. This would carry slate blocks ('clogs') down from the higher levels to the base of the crag where they would be taken out to a loading point for the aerial flight. From here the slate clogs suspended from the flight cables could be carried away to the workshops at the Hause.

Construction of the ropeway itself was started in 1925 and was completed the following year. The ropeway consisted of two terminal piers at either end and five intermediate piers. One terminal pier was situated close to the entrance to what became known as the Honister No. 1 level. The other terminal pier was located adjacent to the buildings at the Hause.

A large amount of the crag face had to be removed part way along the route of the flight to prevent the cargo hitting the rock as it passed by.

At the same time construction also commenced on the internal incline. It would not run for the full length of the Honister slate band, but terminate at the location of 'Long Level', now referred to as Honister No. 6 level. This level had been driven into the crag

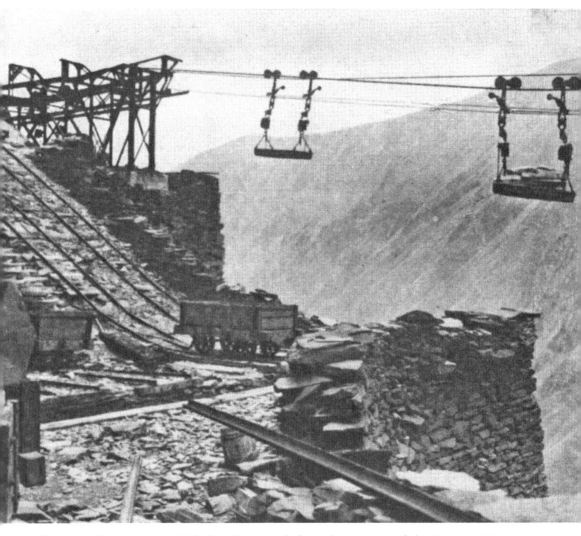

The aerial flight transported blocks of slate rock from the entrance of the Honister Mine to the saw shed at the Hause. The flight was manufactured by White & Sons of Widnes and this photograph was probably taken shortly after the aerial flight was commissioned in 1926. It shows the upper terminal pier of the flight, which was located on a specially constructed ledge on the edge of Honister Crag, close to the exit of Honister Bottom (No. 1) level. Much of this structure still survives as it was in too difficult a location to fall victim to the scrap men.

a short distance above Bull Gill. As a result, much of the higher workings in the crag would not benefit from the new means of transport and the old inclined tramway up the face of the crag had to be retained, at least for the time being.

Quarrymen at Honister watched the installation taking shape with some degree of scepticism, but they soon changed their opinion when it became clear that this rather novel construction of underground inclines and ropeways looked as if it might just work.

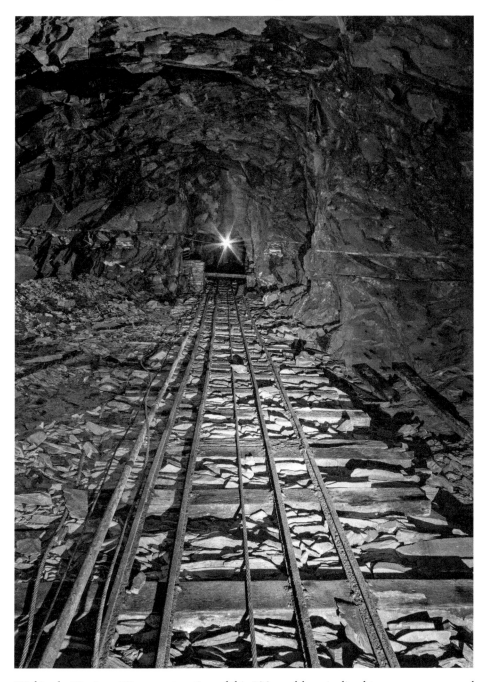

Within the Honister Mine, construction of this 180-yard-long inclined tramway commenced in 1928. The incline was driven through worked out chambers at an angle of 32 degrees to the horizontal and was designed to carry slate blocks (clogs) down to lower levels. The incline only served the Honister band up to No. 6 level. From the bottom of the incline clogs were taken out of the mine and loaded straight onto the cradles of the aerial flight. Construction of the incline took four years to complete.

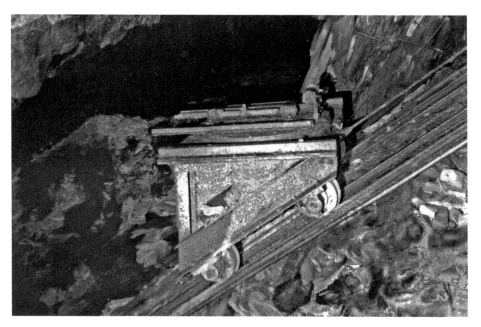

The incline carrier ran from the head of the incline down to Honister No. 1 level. It utilised the outer two rails and carried a truck of slate clog on the top surface, piggy-back style. The counterbalance weight ran on the inner two rails of the incline.

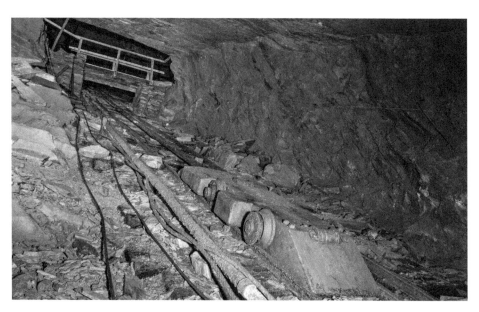

The incline counterbalanced weight, referred to as the Major, is reputed to have been obtained second-hand from a lift shaft in a redundant tower building. The sprocket attached to the wheel is thought to have created a warning sound on the approach of the Major. The counterbalance was sufficiently low in height that it would pass under the carrier at the half-way point on the incline.

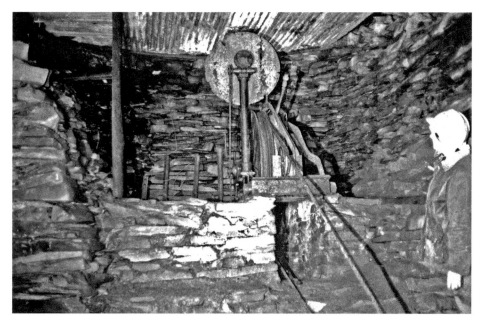

The braking system, operated by a skilled brakeman, was located at the head of the incline. This controlled the speed of descent of the incline carrier and halted the carrier at the appropriate position.

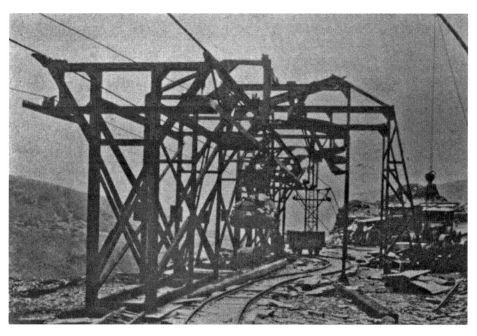

The intermediate loading pier of the aerial flight was sited at the Road End entrance, part way along the course of the flight. It was designed to allow slate clog brought out from the Kimberley workings to be loaded onto the aerial flight cradles.

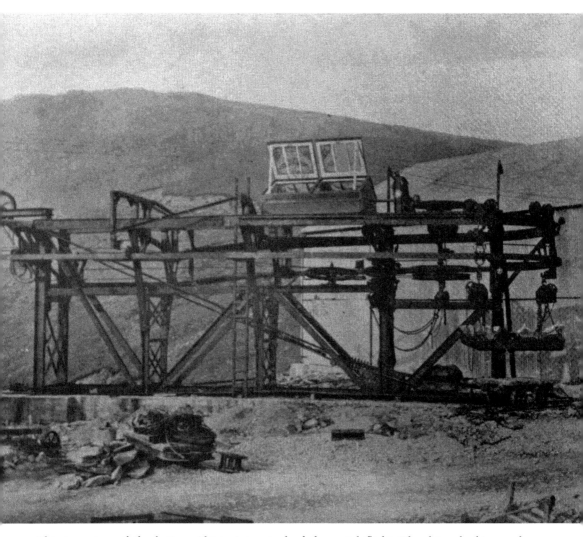

This is a view of the bottom (driving) terminal of the aerial flight. The drive, braking and self-tensioning mechanisms were housed on top of the structure. Little power was required as, for most of the time, the flight was able to work by gravity.

Into the Twentieth Century

In 1932 the decision was made to end production at Dubs Quarry. The amount of quality slate produced had decreased; five men had been assigned to work the open quarries at Dubs but were finding it increasingly difficult to meet production targets. When the site finally closed, the long tramway over to Honister Hause fell into disuse. Part of the track was lifted and much of the equipment at the drum-house was removed.

Within Honister Crag, however, there was a continuing mood of optimism. With the facility established to load the aerial flight at the second pier with slate from the Kimberley Mine, thoughts now turned to the possibility of constructing a second incline within the crag, linking up the workings on the Kimberley vein. By September 1934 the inclined tunnel had been completed. It linked Kimberley No. 1 to Kimberley No. 6 level but it took another four years to install equipment and commission the incline.

This incline did not use a counterbalanced system. Instead, it was electrically powered and was therefore much simpler to operate. An electric motor at the base of the incline drove a winding drum from which a steel cable ran up the incline, round a sheathed wheel at the top and back down to the incline carrier.

Also in the 1930s the technique of diamond sawing of slate blocks was introduced to Honister. This greatly improved the riving process for the splitting of slate as it gave a smooth edge across the slate. A diamond saw was purchased from Messrs Anderson Grice Ltd of Scotland. As soon as it was delivered, their engineer visited to install and commission new plant. The Honister directors were so impressed with Charlie Peebles that they asked him to stay and become chief engineer at Honister. Charlie accepted the offer, little imagining that he would be there for the rest of his life!

As the war years approached, operations at Honister expanded steadily. There was a ready market for roofing slates, tiles and headstones. Both the Kimberley and the Honister Mines were working well and production over at Yew Crag was expanding steadily. The workshops down at the Hause were also on full production. But as the start of conflict approached concern started to grow; few realised that production would stop completely and it would be at least eight years before anything approaching former production levels would return to Kimberley Mine, and twenty-five years before work would start again in the Honister Mine.

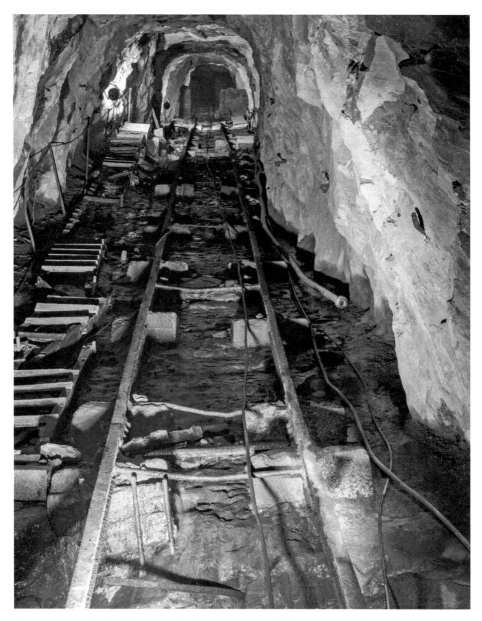

Construction of the Kimberley Incline started in 1932. Much of the incline tunnel was driven through un-worked ground but work progressed well and it was completed in little over two years. Unlike earlier inclines, this was to be a powered incline, with the electric motor and winding drum situated at the foot of the incline.

In 1957 the decision was made to move the motor and drum from the base to the head of the incline. This intricate operation was planned to take place over a weekend to avoid affecting production from the mine. It was overseen by Charlie Peebles, the mine engineer. As soon as production ceased on the Friday evening Charlie took over the operation and by late on the following Sunday work was complete and the incline was ready to be used again on the Monday morning. The incline was last used in approximately 2010.

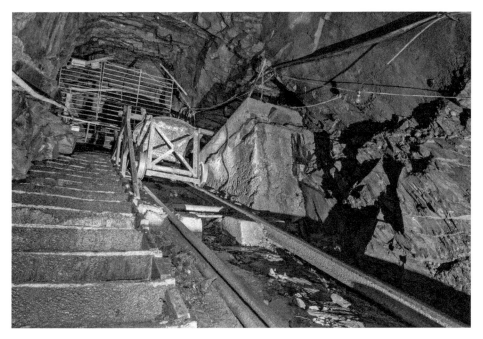

The incline carrier transported slate trucks from the various access stagings of the incline down to the incline foot.

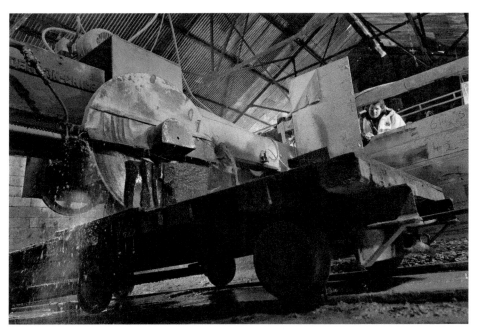

In 1934 a new stone-saw was purchased from Anderson Grice Ltd, of Carnoustie, Scotland. The saw was installed in Honister's saw shed and remained in use until 2016. (Honister Slate Mine)

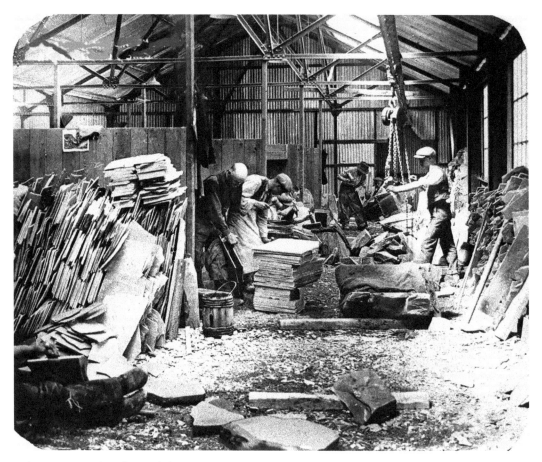

A busy scene within the workshop at Honister Hause. (Honister Slate Mine)

The War Years and Afterwards

The war years took their toll on Honister as they did on many other non-vital industries. Many Honister men were enlisted into the forces. Those who remained at the mine struggled to keep the site operating, especially when it involved repairing equipment that had broken down or processes that required a lot of power such as the mine lighting, the saws and the aerial ropeway. Eventually production ceased altogether, not to be resumed until peace returned.

In 1946 the directors of the Company returned to Honister and carried out a rapid but effective survey of the site. They soon realised that the workings associated with Honister Crag were in such a poor state that they had to be temporarily abandoned. As a result attention turned instead to getting production up and running as quickly as possible in the Yew Crag quarries and mines.

Within a few weeks supplies started to arrive. Among the first items were new rail track and a complete new rope for the incline system. Cranes were re-wired and machinery overhauled, and despite limited resources and a lack of skilled men, the first consignment of roofing slates left the site in April 1946. Yew Crag was now to be the main production site and would be for many years, but it took almost four years to get Yew Crag up to acceptable production levels, although sadly this achievement was not without accident and mishap.

At the same time major alterations were made to the inclined tramway at Yew Crag. There was no need to maintain the incline up to the former winding drum and the upper section was abandoned. The incline operation was also converted to that of a powered incline with the electrically powered winder installed at the incline foot. In this way the incline could continue to serve the closeheads that worked the Kimberley slate band within the crag, but with much reduced maintenance costs.

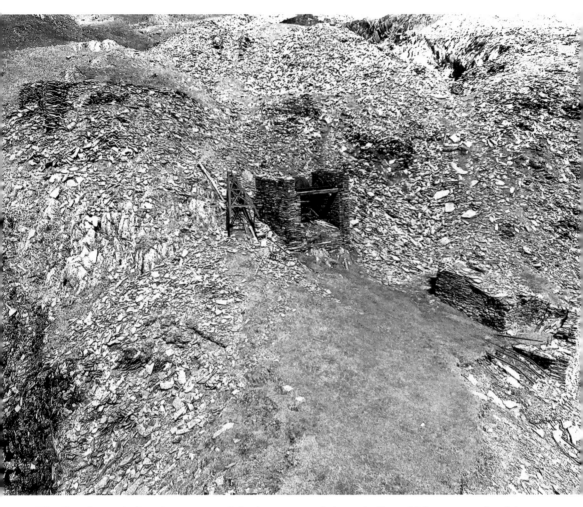

The Yew Crag winding drum operated the long counterbalance incline which was completed in 1880 and was designed to carry made slates from the riving sheds scattered around the higher areas of Yew Crag down to the end of the access roadway that led to the Hause. The incline operated in this form for seventy years, although a new winding rope was installed when production at the site recommenced shortly after the end of the Second World War. (Mark Simpson)

In 1950 attention turned to re-commissioning some of the workings within Honister Crag. As a start an inspection was carried out by one of the directors and the chief engineer. Results were not good: the floors of working chambers were littered with fallen blocks from underground collapses; much of the compressor pipe-work and cabling had been stripped out for use over at Yew Crag; one of the aerial flight towers had toppled slightly and was found to be 10 inches out of alignment; and the mine roadways were also in a poor state. But despite these problems work started in earnest, although it took a further five years before slate production could start again in the Kimberley Mine within Honister Crag.

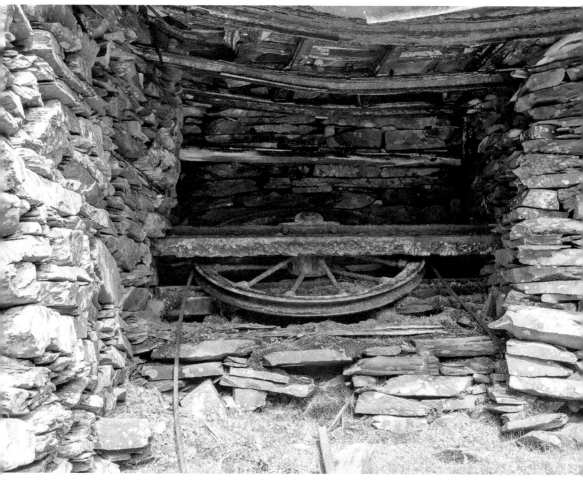

In 1950 the counterbalance system on the Yew Crag Incline was replaced by a powered system. The upper few hundred feet of the incline were abandoned and the sheathed wheel, shown in this photograph, was installed lower down, close to No. 6 (New England) level of the Yew Crag Mine. A winding drum, driven by an electric motor, was also installed at the incline foot. The incline was extended downwards to a terminus where a tramway, operated by an electric locomotive, pulled trucks of slate to the Hause. These changes were able to be made when the open-top workings beyond the original winding drum were closed down and extraction concentrated on the mines within the Kimberley vein at Yew Crag.

As the road network in the region was steadily improved it became much more common for road vehicles to collect orders from the Honister Mine and deliver them directly to customers in the North of England. This meant that there was far less dependence on rail transport. Transport at the mine site also improved significantly. A number of mine roads capable of taking heavy trucks were established from the Hause up to Kimberley No. 1 level entrance ('Road End') and also up to Kimberley Top Level and Hopper Quarry.

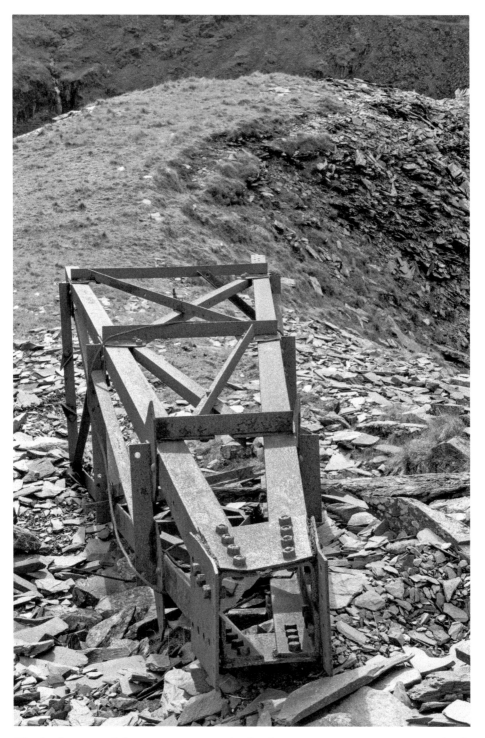

The derelict state of the Yew Crag mining levels after operations at Yew Crag were finally halted in 1962.

By 1960 the mining of slate from Yew Crag had all but finished, with final closure occurring in 1962. The last areas worked were the underground closeheads on the Kimberley slate band; the open quarries high on the fell to the north-west, which had been worked since the late eighteenth century, had ceased production several decades earlier.

Over on Honister Crag the closeheads on the Kimberley slate band continued to be developed, and during the summer of 1963 parties were sent up into the old workings on the Honister slate band to assess the state of the underground areas, to see which chambers could produce workable deposits of slate and to check the old counterbalanced incline mechanism.

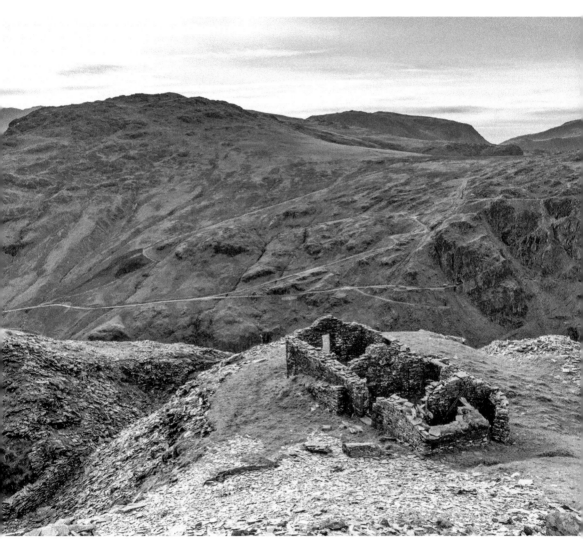

The buildings on the higher fellside of Yew Crag consist of the remains of bothies, riving sheds and storage areas. Many would have been in use until the early 1960s. They became redundant when the extensive quarry workings high on Yew Crag were closed down.

Within four months several chambers had been cleared and were ready to produce slate clog again and the incline was back in working order. Later the same year a short section of rail track was installed close to the old terminal pier of the aerial flight to link the track exiting the Honister Mine with the Link Level. On New Year's Eve the first slate clog in twenty-five years was brought down to the Hause from the workings on the Honister slate band within the crag.

The Company was also keen to introduce new products and not to rely entirely on roofing slates. To help with this a new polishing machine was ordered and delivered in September 1965. This machine, of a type popularly known as a 'Jenny Lind', would assist in producing the mirror-like finish required for decorative slate products. The machine remained in use for over fifty years until, in 2017, it was removed and replaced with a new polisher during the Christmas shutdown period.

Ownership of the Honister Mine was to start changing. Successive lease holders were keen to have a go, and this ended the much more stable periods of operation of past centuries. In 1967 Lord Egremont took over the operation of the Honister workings, taking an active part in the site's operation as managing director.

The old 'Jenny Lind' polisher installed in 1965 was finally removed and replaced with this new machine during the Christmas shutdown period of 2017.

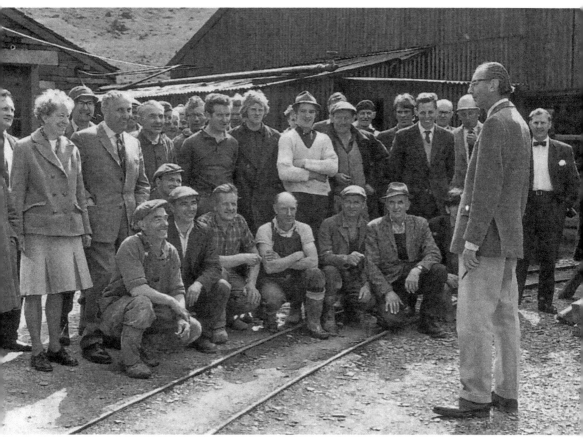

Lord Egremont addressing the Honister workforce. (Honister Slate Mine)

Another change took place in 1981, when Bernard Moore, whose family had interests in ore mining elsewhere in the North of England, took over the lease. Bernard had been operating the Harnisha Burn Lead Mine in Weardale, which he closed down before moving to Honister.

Bernard installed a large static caravan behind the buildings at the Hause and also a large and fierce dog to protect his site. Additional equipment was acquired and work progressed well at the mine for the short period of Bernard's operation. Four years later McAlpines, operator of the Penrhyn Quarry in North Wales, made him an offer for Honister that he couldn't refuse. Subsequently, he went on to run a geophysics company and formed a mining consultancy. In 1997 he bought a small farm in Wales and took up an interest in Welsh gold mining operations. But he never lost his connections with Cumbria and at the turn of the century he became manager of the Middle Ruddings Hotel in Braithwaite village.

Despite the fact that he was only at Honister for four years, Bernard progressed the mine well. He introduced new concepts and new machinery onto the site and was keen to develop the Hopper Quarry area, which had been converted from a small

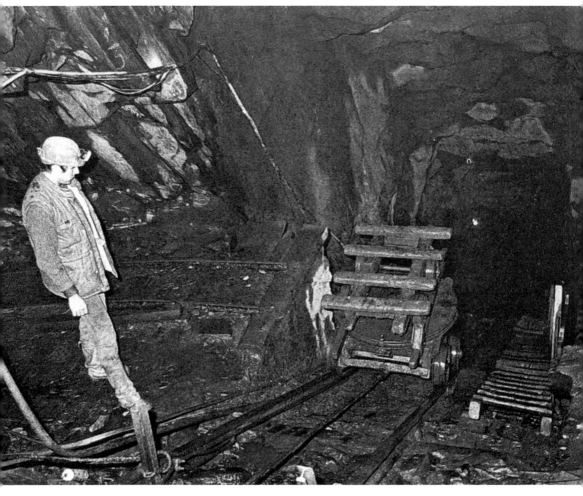

The date is 1983 and Bernard Moore, owner of the Honister Mine, awaits the arrival of a slate bogey, which is being brought up the incline on the incline carrier. Once the carrier has reached the correct position the bogey will be rotated to line up with the rail track running into the level. (Honister Slate Mine)

underground closehead. He also had plans to drive a new tunnel from the Hopper Quarry through the high ground behind to intersect the old workings of the Honister vein within the crag.

Bernard also had a somewhat Machiavellian character. There are the remains of a bait cabin high on the fellside close to Hopper Quarries, which was used by the employees for shelter during break periods when working in the area. Late one extremely wet night, in an effort to start the pumps that kept Hopper Quarry clear of water, Bernard used black-powder explosive that he carried in his Land Rover to remove the lock from the door of the hut as he had left the key down at the Hause. The hut was more or less wrecked in the process.

The tin bait cabin and storage shed, which was accidentally destroyed by Bernard Moore when he used black powder explosive to remove the padlock from the door.

The Close-Down

McAlpines was keen to include the Lake District's volcanic slate within its product portfolio. The company soon realised that the only economic means for them to do so was to quarry slate by means of open-cast workings on the upper shoulder of Fleetwith. A boring rig was called into service and was worked for several months, taking core samples from the fell for analysis.

Results were not satisfactory. It became clear that large-scale, open quarry extraction, as planned by McAlpines, was not going to be economic. Honister was much more suited to being worked by mining, and on a much smaller scale. In 1986 operations ceased. The site was mothballed and most of the slate workers were made redundant. Included was Honister's head river, John Taylor. John subsequently moved to Kirkstone Quarries, where he worked until he retired. If anyone had told him at that time that he was going to play a hugely significant part in the future development of Honister, he would not have believed them.

Eventually, in December 1991, McAlpines decided to abandon Honister completely and an advertisement was placed in the *Quarry Manager's Journal* offering the Honister lease for sale. Very quickly this created quite a bit of interest locally as there were a number of small groups who might be keen to 'have a go' at starting slate extraction again. But enquiries showed that the sum being asked was into five figures. Most considered it an unrealistic amount and felt that it was the last nail in the coffin for the Honister Slate Workings. However, they were all to be proved very wrong.

The shoulder of Fleetwith, which was destined to become an open quarry as a source of light green volcanic slate for McAlpines.

Mark Takes Over

It took some time before there was any movement on a sale. In fact, it was not until 1997 that news started to filter out of Borrowdale that McAlpines no longer held the lease. Against all odds it had been taken up by a local entrepreneur. Mr Mark Weir and a colleague, his Uncle Bill, had managed to obtain the lease and had put together plans to start up the Honister Mine again, and to repair the workshops at the Hause to handle slate clog from the mine.

Mark Weir was a Borrowdale lad – and he always made sure people were aware of that! He was born at High Lodore Farm, Borrowdale, a sizeable fell-farm where his father held the tenancy from the Lodore Estates. His mother, Celia, originally came from Coniston, where her father had been a slate quarryman, working at The Old Man Quarries.

During his formative years Mark had little interest in 'traditional education'. Even at a young age the boy was clearly destined to be an entrepreneur. His early life is well documented in the publication *Honister Slate Mine, The Brilliant Darkness* by Celia Taylor Weir, Mark's mum. After leaving school Mark tackled a number of tasks including farming, operating a contracting business, digging graves, working as a chef, a helicopter pilot and running a pub, but none of these enterprises held any long-term vision for him.

Mark was extremely fond of and close to his grandfather, known as 'The Boss'. Mark's outlook and career took a major turn on the day he offered to fly The Boss in his helicopter on a tour of the sites in the district where he had worked as a slate quarryman. The trip started off in Low Furness and then proceeded to Coniston Old Man. The helicopter hovered for some time over Colt Crag, allowing him to view all the workings of the Old Man Quarries.

They then flew on over the fells to Honister. At that time Honister Quarries had been closed down by McAlpines. Mark's grandfather could not believe the scene that he saw and kept asking his grandson why they had closed. Mark was not sure either but felt, in deference to the old chap, that he should find out. His investigations ultimately led to a meeting in a hotel room in Manchester where Mark, after a few minutes of thought, signed a document allowing the lease for Honister to pass to himself.

Over the next few months the partners put in a huge amount of effort to bring the mine, the workshops and the mine road back into working order.

Eventually, during the last few weeks of 1997, and after a break of almost twelve years, a quantity of slate clog was brought down the mine road from a chamber in Kimberley Top Level for processing at the Hause. Honister had started again!

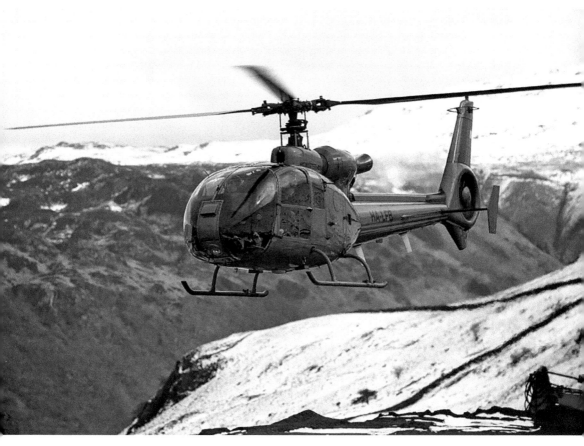

Mark Weir flying over the Borrowdale fells. (Honister Slate Mine)

Life Returns

Bringing the site back into full production was a nightmare for Mark. He quickly realised that he now owned the lease of a derelict mining and production site in the wettest place in England. Despite this, within a few days of returning from his meeting in Manchester Mark started work to bring the site back to life.

Although he had little knowledge of slate mining, it was very clear to him that his first task was to clear the debris and damaged equipment that had accumulated over the previous twelve years. Using a small digger, which he transported up to the mine, he cleared blocks that had fallen onto the floors of the main mining chambers in the crag so that some degree of working the Kimberley vein could be re-started. The mine tunnels leading to the outside world also required attention and rail track needed to be repaired or replaced.

The workshops and offices at the Hause required gutting almost completely and the roof needed repairing so that those working at their desks could do so without the need to wear waterproof clothing and headgear on wet days.

Mark was warmly congratulated by family and friends when the first consignment of slate clog was brought down to the Hause on 18 December 1997. It was a significant moment and he and his business partner had done well. One family member who was present was his recently retired uncle, John Taylor, a former slate quarryman. On viewing the rock brought down from the Kimberley Mine, John quickly realised that he was going to have to forget retirement for a while and take on the role of 'mine trainer'. Mark was very grateful for his help as John explained to him exactly where the best rock was situated in Kimberley and the best way to drill and blast to obtain intact clogs that were suitable for riving.

One strong recommendation made by John was to use wire sawing to assist in detaching slate rock from the face in the mine. This technique involved inserting a continuous saw-wire along channels previously cut behind the face of the rock to help detach the block from the face with the use of a minimum amount of explosives. The wire was impregnated with industrial diamonds, which greatly speeded up the cutting process. In 1998 the two partners, impressed by Uncle John's recommendations, decided to purchase a wire-sawing unit and drove to Italy themselves to pick it up from the manufacturers at the Carrara marble mine in northern Tuscany. The trip included a training session carried out by the team at Carrara in the use of wire saws.

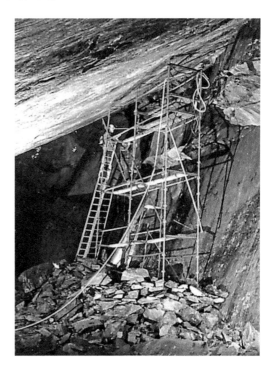

Mark clearing loose rock from the sill in Kimberley No. 6 level. (Honister Slate Mine)

John Taylor, Mark's uncle, who became his mentor during the early years of the operation of the Kimberley workings in Honister Crag. (Honister Slate Mine)

Bringing the plant and equipment back to life was not the only issue that required urgent attention; a workforce needed to be enrolled to operate the mine and the offices, and the new recruits would require expert training. Initially family and friends were recruited, but soon after mining recommenced Mark decided to take on people to fill three key positions: a head river, an office administrator and a skilled slate worker trained to produce polished tiles and other decorative products. All three remained working at Honister for many years.

Sadly, the enthusiasm for bringing the site back to life was not shared by everyone. Some of those who were involved in the tourist industry in the area were concerned that Honister's re-birth was going to introduce an element of 'industrialisation' into Borrowdale, which would be inconsistent with their attempts to market the area as a major unspoilt tourist venue. During the early years of Mark's work at Honister, local authorities also showed little enthusiasm. Mark's attempts to negotiate with them frequently developed into stand-up arguments.

Fortunately there was a rising tide of concern beginning to develop that the Lake District could deteriorate into a single-industry region, with all the risks that this could bring. A certain degree of reluctant acceptance of the dangers of relying entirely on

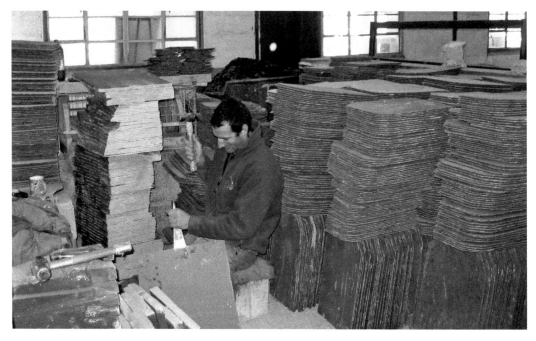

Martin Nicholson started his career in the slate industry as an apprentice river-dresser at Honister in 1985. Two years later, when Honister was closed down by the owners, McAlpines, Martin was fortunate enough to move to Kirkstone Quarries where he was able to finish his apprenticeship. Having done so he took on other skills at the Kirkstone Company, including the production of decorative slate products. In 1999 Martin returned to Honister, where his career had started fifteen years earlier, and helped Mark Weir to get the production side of Honister going again. In this photograph he is finishing off a day's riving. In 2010 Martin set up his own operation at the old Threlkeld Quarry site near Keswick. (Honister Slate Mine)

tourism began to build up in the area. Sadly, this was not soon enough to prevent the loss to Keswick of the Cumberland Pencil Factory because of difficulty in expanding the production facilities at their site in the town.

Within eighteen months of Mark Weir taking on the lease for Honister, the National Park Authority became aware that he was obtaining slate by mining. A small quantity was also being obtained by re-processing spoil taken from the old surface tips. However, the consent Mark had inherited from the previous leaseholders was to obtain slate by open-cast quarrying on the surface of Fleetwith. Mark had considered from the start that this was a retrograde step and it was much better from an environmental point of view to obtain slate from underground mines, rather than to 'take the top off Fleetwith'.

Arguments on the terms of the lease continued for several years until it was agreed between Mark and the planning authority that all aspects of the lease should be reviewed by one of Honister's team who was experienced in planning matters, and also by a well-regarded compliance planning officer working for the Authority. This worked, and by 2014 terms were agreed that conformed to the requirements of both the Honister Slate Mine and the Authority.

In 2003, with the mine now producing well, Mark Weir turned his attentions to the possibility of setting up guided tours within Honister Crag. These would introduce those visitors interested in the history of the Lake District to one of the Lake District's oldest industries. A set of guided mine tours were established in the lower part of the Kimberley Mine, well away from the present-day working area. These tours proved an immediate success and, during the winter of 2017, were enhanced by the use of ultra-modern audio-visual techniques installed at various locations along the route.

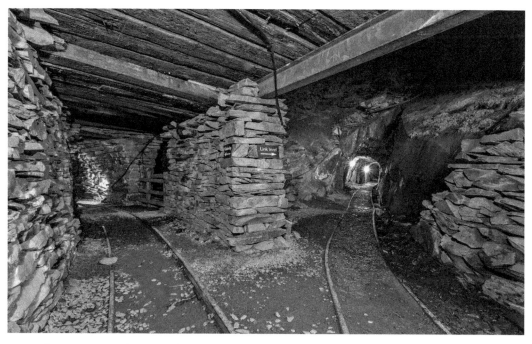

The entrance to the Kimberley Mine used by visiting parties.

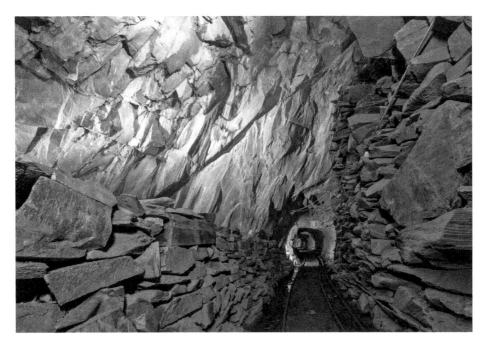

The 300-meter-long Kimberley No. 1 level, taken by visitors before entering the main chamber within the level.

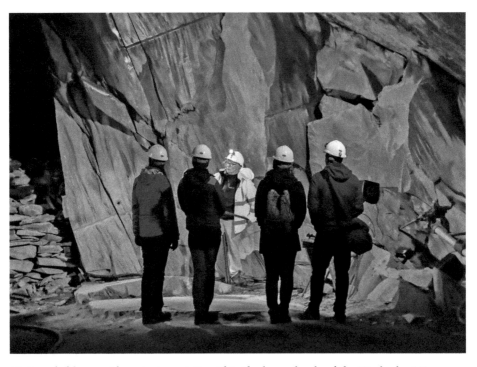

Visitors, led by a guide, enjoying a trip within the lower levels of the Kimberley Mine.

Mark was also aware that much of the history of the site lay on the surface, including out on the face of Honister Crag itself. The long route of the former Honister Crag inclined railway was still present on the crag, but the trackbed was in need of repair in several locations. However, if this could be carried out, and the route made safe, it would provide an enormous amount of information for those keen to learn more about this unique Victorian feature and the conditions in which slate quarrymen lived and worked on the crag at that time.

Members of Honister's team who were also mountaineers suggested to Mark that the feature should be referred to as a 'Via Ferrata', a term used for many of the adventure routes on mountains in certain parts of the Alps, where they are described as 'a climbing protected path, with iron cables and iron steps or ladders, along the natural conformations of the Dolomites walls'. This seemed to describe very accurately the feature Mark intended to install.

Eventually two routes were installed, one in 2007 on the trackbed of the old railway and the second on ledges and 'natural conformations' on the crag face in a very similar fashion to those that exist in the Dolomite Alps. This became known as the Via Ferrata Extreme.

The route that followed the trackbed passes through areas of extreme historical importance. For this reason a set of five interpretation panels were installed at suitable locations along the route, providing visitors with interesting historic information about the areas the route passes through.

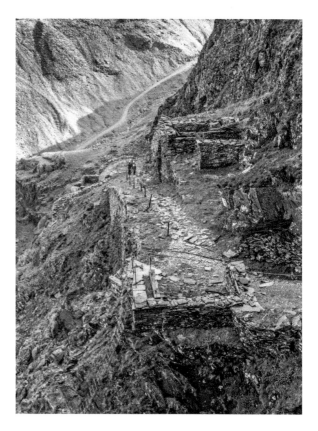

A group proceeding up the Via Ferrata Classic. Much of the route follows the trackbed of the historic Honister Crag tramway.

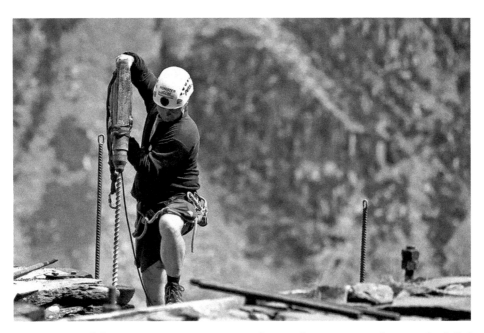

Construction of the Via Ferrata Extreme required a significant amount of extremely skilled engineering work. Honister Slate Mine Ltd was very fortunate in that they were able to secure the services of Gavin 'Gnash' Baxter, a local engineer specialising in constructing this type of engineering feature. (Image from the late Martin Campbell via Honister Slate Mine)

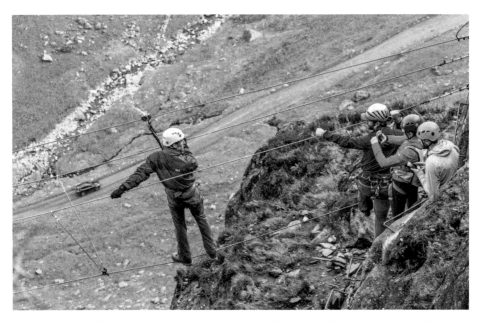

The extremely adventurous route of the Via Ferrata Extreme, although appearing daunting, is in fact perfectly safe so long as the belaying instructions are correctly followed. This has now become one of the most popular adventure routes in the district.

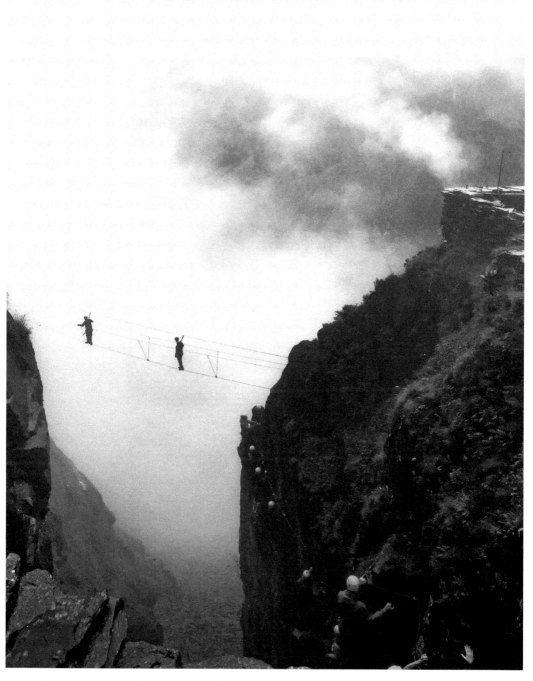

A group proceeds along a section of the Via Ferrata Extreme on a wet and misty day. (Honister Slate Mine)

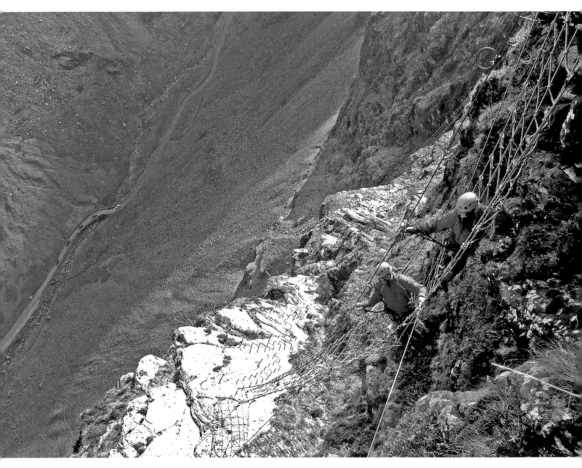

Ascending the climbing net, a feature installed part-way along the Via Ferrata route. It is very unlikely that drivers on the Honister Pass Road far below will have any idea of the adventure groups above. (Tiger Weir, Honister Slate Mine)

Part of the mine operating agreement that was made between Mark and the planning authority involved the facility to crush waste stone to produce slate chippings, which could be sold for decorative uses. This required a crusher to be purchased and installed. Initially the crusher was located at the stockyard at Honister Hause but this created difficulties in that rock for crushing was transported down to the Hause from the mine and that the material that was unsuitable for crushing was then disposed of by tipping at the Hause. The obvious location for the crusher was up at Hopper Quarry, close to the entrance to the mine. This become part of Honister's operating agreement and the new crusher was installed at the Hopper site in 2004.

At the same time work also started to modify the entrance to Kimberley No. 6 level. This level was the main exit from the mine for slate clog en route to the workshops and had previously been of the usual dimension for a rail tunnel – approximately 6 feet high and 4 feet wide. Clearly, as the mine expanded, this would set severe

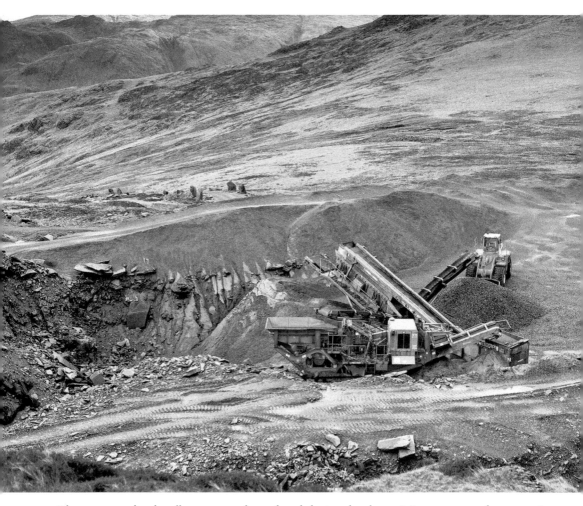

The stone crusher handles waste rock produced during the slate mining process and converts it into stone chippings for industrial or decorative use. The crusher is conveniently sited at Hopper Quarry, close to the present entrance to the slate mine.

limitations on operations, especially as the most suitable method of transporting a large clog of slate was in a single journey from the working face to the saw shed at the Hause.

Mark realised that the entrance must be enlarged to allow heavy trucks to drive directly into the working chambers in the mine. Once this work had been completed the efficiency of the transport of slate improved significantly and, in addition, waste rock could be transported easily from the floor of the chambers to the crusher.

The enlarged entrance also allowed him to indulge in a small amount of light-hearted frivolity one evening in July 2009. This was in the form of a banquet in a temporary restaurant installed within the enlarged No. 6 level that was referred to locally as the Dine in the Mine event.

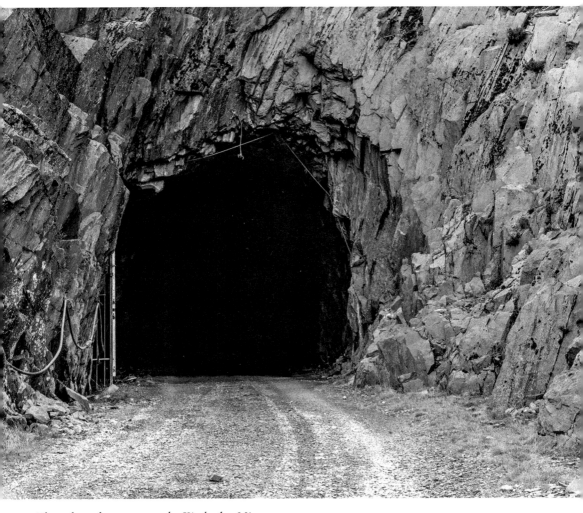

The enlarged entrance to the Kimberley Mine.

Dine in the Mine was not the only culinary experience that the Slate Mine established. In about 2008 the Yew Tree restaurant at Seatoller was purchased by the Honister Slate Mine Company and re-opened. It very quickly became popular with visitors as a café bar, as well as an evening restaurant.

For a period of time the evening meals took on an international 'flavour', in particular being based on Afrikaans cuisine, with Michelle Bourgard, a South African, being employed and trained as the chef.

From time to time the weather in this part of the Lake District can cause enormous problems for operations. Although the mine itself is not directly affected, being located some distance underground, the mine road that runs down to the Hause can require constant attention during spells of heavy rain. Occasionally Honister can be cut off completely when flooding occurs in the Borrowdale Valley.

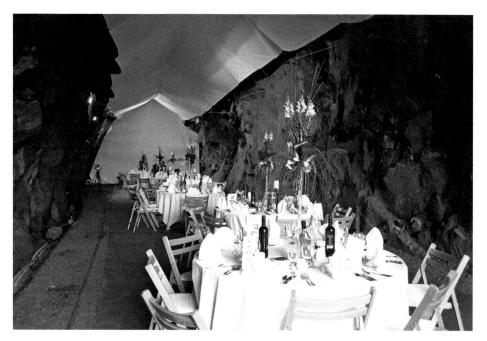

The 'dining room' set up in the entrance to Kimberley No. 6 level is ready for invited guests. (Honister Slate Mine)

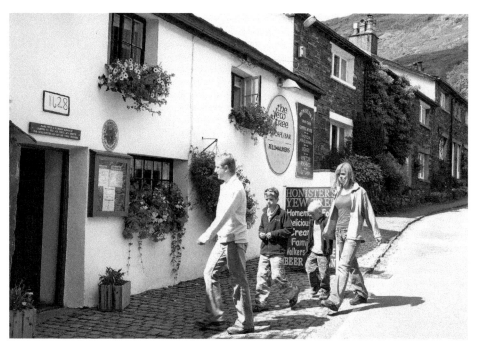

Guests arriving at Honister's Yew Tree Restaurant in Seatoller, at the foot of Honister Pass. (Honister Slate Mine)

Winter weather can also create challenging conditions. Although access to the mine is normally not a problem under snow, the Honister Slate Mine Company frequently has to grit the Honister Pass Road itself to allow traffic to access the site from the Borrowdale valley.

A major problem that had to be solved was the lack of electricity supply from the National Grid. All power for the operation of the machinery, both in the mine and at the Hause, had to be generated on site. Moreover, to avoid the laying of costly three-phase cabling, power had to be generated in more than one location. Generating equipment was set up at the Hause, at the entrance to Kimberley No. 1 level and also near the top of the crag at Kimberley No. 6. Diesel fuel for the generators was brought by road from Keswick.

In 2010 Honister embarked on a project funded by Government grants to replace some of its reliance on fossil fuels with energy from renewable sources. The initial energy sources investigated were water, wind and solar power. The last of the three was quickly eliminated but extensive investigations were carried out into the feasibility of using either wind or water power, or a combination of both. Despite being situated at the wettest place in England, water power alone was felt to be limited, but a combination of water turbines and low-head wind turbines was considered to offer a cost effective alternative to diesel.

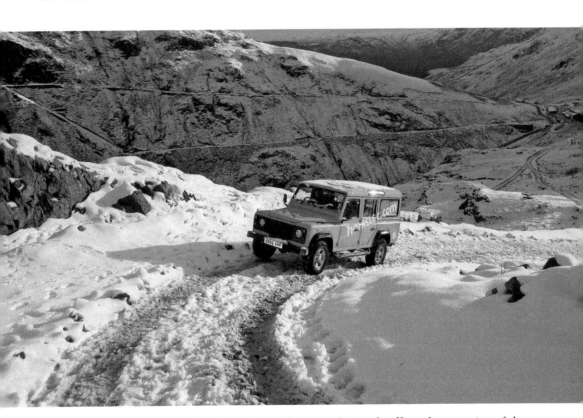

The Honister area receives its fair share of snow; however, this rarely affects the operation of the slate mine as the Company's Land Rovers, fitted with wheel chains, are able to access the main mine entrance under most conditions.

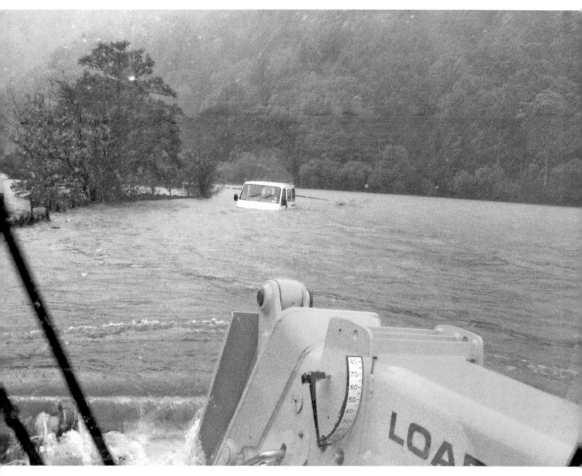

A wet day in Borrowdale. The date is 22 October 2008 and Mark Weir uses one of the mine vehicles to access a minibus abandoned and virtually completely submerged on the main valley road. He was concerned with making sure that no occupants remained inside. Fortunately the minibus was empty, as all those on board had escaped before flood water trapped them.

This particular incident occurred on the same day as a major mountain race took place. Many of the runners taking part in the Original Mountain Marathon (OMM) were overcome by the severe weather. It was reported that over a foot of rain fell during the storm and in the region of 300 runners took shelter in the mine buildings at Honister, and another 400 in farm buildings at nearby Gatesgarth Farm.

However, the most serious effects of such events are almost always felt by the local community to whom Borrowdale is home. (Honister Slate Mine)

Unfortunately, despite the benefit that the results of the project indicated, authorities were unhappy about the installation of the low-head turbines on the Honister site because they would be visible from the surrounding area, and as a result the project was closed. The site continues to the present day to be powered by electricity generated from diesel fuel.

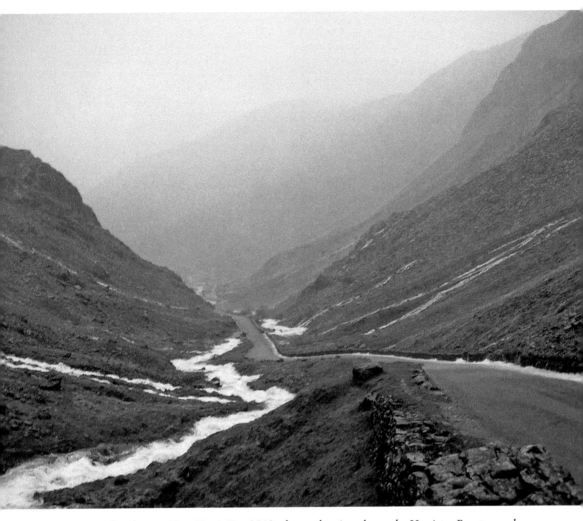

This photograph, taken on New Year's Eve 2013, shows the view down the Honister Pass towards Gatesgarth Farm in the valley below. On this particular day flooding was extremely serious in both the Lorton and Borrowdale valleys. Once the floods had subsided it took several days to clear rubble and repair the roads. (Honister Slate Mine)

With the completion of the modifications to the entrance to No. 6 level, and improved access to the mining closeheads, output from the mine continued to develop steadily. Revenue from sales of slate and slate products was increasing, and much of this was helped by the conditions placed on planning consents by the National Park Authority. They required all new-builds to be roofed in local slate. The requirement for decorative slate products was also increasing steadily and Honister slate had a very attractive appearance when polished.

With things now progressing well in the mine, Mark's attention turned to developing further adventure facilities for visitors.

Mark was very aware of zip wire installations that had been set up in various tourist locations in Europe. He knew of the facility that had been installed above Grindelwald in the Swiss Oberland. This ran from the mountain peak known as First to the village of Schreckfeld. It was 755 meters long and had become known to those keen on such adventures as the 'First Flyer'. Mark realised that a similar facility on Honister Crag would allow those who had completed the Via Ferrata courses on the Crag to return to the car park at the Hause quickly and easily. The full length of the zip wire would be 1,200 meters, the longest at that time in the northern hemisphere.

Mark wasted no time in getting a project team set up and selected key people to become partners in the project. It was planned to install the upper pier of the incline at a location on the summit of Honister Crag known as Black Star. The lower terminal pier would be adjacent to the saw shed at the Hause. A planning application was submitted to the planning authority, the National Park Authority, on 1 June 2010. Following concerns expressed by Natural England about the environmental impact of such a scheme the application was withdrawn by Mark on 21 October 2010 'to allow the applicant to explore a solution to the issues of nature conservation'.

Despite this setback Mark decided to persevere and drew up plans to overcome the issues raised. Sadly, within months, his work on this would come to an abrupt end.

At the same time as the planning application was being considered a film company, Platform Productions, was proposing a series of 'fly-on-the-wall' documentaries for BBC 4 on planning issues within British national parks. Richard Macer, the director of the production unit, commented that, 'In particular they were looking into the idea of conflicts within national parks.' Clearly the situation at Honister fell directly into this remit and Mark was happy to take part.

Richard Macer rapidly gained considerable respect for Mark, commenting that, 'He had a lot on the line because he had built Honister up into an extremely well liked local business.' As the issues developed Richard was allowed to film the campaigning meetings and confrontations that took place between Mark and those objecting to the proposals. A brave but unsuccessful attempt by the National Park Authority to mediate and find a common ground was also captured on film. Work by Honister's project team continued to prepare a second application that took account of the objections made the previous year.

The Accident

Life at Honister carried on as normal while the second application for the zip wire was being prepared. During this period Mark had offered to help a local business that was planning to construct slate features on their property. On the evening of 8 March 2011 he had stayed a bit later than he intended. Mark drove back up to Honister to leave his vehicle and use his helicopter that was parked on the helipad to get home quickly. He briefly telephoned home to say that he was leaving Honister and took off just after 7 p.m. for the ten-minute flight home.

Sometime later, when he had not arrived home, Mark's partner, Jan Wilkinson, contacted a member of the Honister staff, who lived at Seatoller, at the foot of Honister Pass. The staff member, and a colleague, went up to the mine and noticed that Mark's vehicle was parked as normal and that the helipad was empty. The pair then went into the offices and studied the CCTV recording from earlier in the evening and noticed that the helicopter had taken off to fly in the direction of Gatesgarth, as normal, but a few seconds later had returned and appeared to head down towards the Borrowdale valley, at which point the aircraft went out of the view of the CCTV cameras.

Soon after that Mark's partner contacted Cockermouth Mountain Rescue Team. A search was commenced, in conjunction with the Keswick team. The rescuers located the wreckage of the helicopter shortly after midnight.

The following morning those members of the Honister team that were not due to be on site were telephoned and notified of the accident. They were also asked to try to attend a meeting at the Mine offices on the following day, 10 March.

It is extremely commendable that the family decided, almost immediately, that the Honister Slate Mine business would continue to operate and projects and future strategy would be progressed as planned. It was also agreed with Richard Macer of Platform Productions that the Weir family were prepared for him to continue with the filming and include reference to the helicopter accident in the film. Honister Slate Mine would also continue to prepare the second application for installing a zip wire. Platform Productions attended and filmed the debate at the 10 March team meeting.

The funeral of Mark Weir was held on 22 March 2011 at St John's Church, Keswick, which was full to capacity, with many who wanted to be present standing at the back of the church. All the Honister team attended. His body was laid to rest at St Andrews Churchyard, Stonethwaite.

Mark Weir relaxing on Fleetwith Pike.
(Honister Slate Mine)

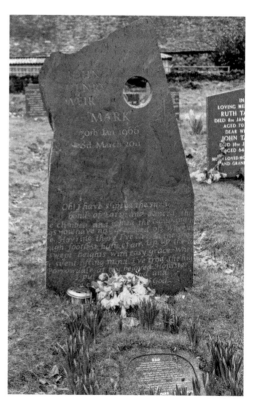

The headstone, and stones holding additional
text, at Mark's resting place.

Earlier in the year, Mark Weir had also been posthumously honoured with Cumbria Tourism's Personality of the Year Award at a ceremony at the Rheged Centre, Penrith.

The second application for the zip wire was submitted to the Lake District National Park on 21 March 2011. The application included information on precautions that would be taken to counteract the environmental concerns that had been voiced after the first draft had been reviewed by the authorities.

The application was considered by the Authority's development control committee at their September 2011 meeting. Platform Productions was allowed to film the whole event, which, again, was commendable. The public area of the meeting room was packed with supporters and opponents of the zip wire application.

However, despite the amendments, the proposed precautions were felt to be insufficient and there were also considered to be issues relating to the effect on the solitude of the area at the launch point of the zip wire on the rim of the Crag; namely, that the harm would be greatest at Black Star, which is particularly remote and tranquil. After lengthy debates the application was refused by nine votes to five.

By the time filming was complete, and the programme put together, Mr Macer had clearly become extremely moved by Mark's feelings for Borrowdale, Honister and the welfare of his own local community. He commented that

Mark was a unique person, and even though people had strong feelings for and against him, I would hope they would look back on him as being a force for the good. He brought an ancient mine back to life, provided work for local people and introduced a genuinely different sort of tourism experience for residents and visitors that isn't available anywhere else.

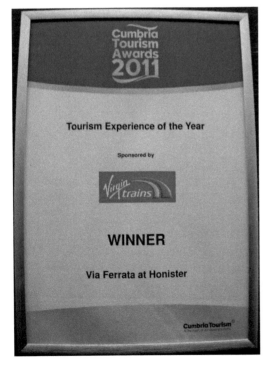

The Tourism Experience of the Year was presented to the Honister Slate Mine in July 2013. The presentation was made at the Rheged Centre, Penrith. (Honister Slate Mine)

Separate to the zip wire application, during the same year Honister Slate Mine appeared at Workington Magistrates' Court charged with installing the Via Ferrata feature on Honister Crag, which had subsequently damaged areas of Special Scientific Interest. Honister received a substantial fine but magistrates stressed that Natural England and the Lake District National Park Authority should work closely with Honister to resolve the situation and retain the Via Ferrata feature rather than the court imposing a restoration order on Honister to remove it altogether.

Despite the high fine levied, this result was a good outcome for Honister. Because of the court's request, both Natural England and the National Park Authority felt duty-bound to work with the Honister Slate Mine. This led to a project team being set up, which worked on modifying the route, and eventually the Via Ferrata was re-opened for keen energetic visitors.

The final chapter in the death of Mark Weir was closed on 25 March 2013. At an inquest held at Cleator Moor, the coroner concluded that even though Mark was 'an experienced pilot of above average ability', his death 'was an unexplained accident'. This followed evidence provided by the Air Accident Investigation Branch, which had investigated the events of the night of 8 March 2011 in great detail.

The Aerospatiale Gazelle helicopter being piloted by Mark Weir on 6 March 2009. During the inquest into Mark's death, almost exactly two years after this photograph was taken, it was stated that his death 'was an unexplained accident' and that 'there were no mechanical issues detected with the aircraft'. (Honister Slate Mine)

Honister Recovers

Work continued at Honister after the death of Mark Weir with hardly a break. His brother, Joe, who had assisted frequently at the mine, immediately took on the full-time role of director. Projects that had been temporarily abandoned were re-started. Mark's fundamental ethos and passion to create 'real jobs for local people who had been born and educated in this valley' was clearly going to be retained by the Company.

An immediate priority within the mine was to source consistent slate. Since the mine re-opened in 1997, Kimberley No. 6 had been the main source of slate clog, but from time to time the quality had temporarily deteriorated. In a bold move Joe Weir decided that the Kimberley No. 5 level, running below Kimberley No. 6, was worth trying. Previously, for reasons unknown, the 'old men' had not driven Kimberley No. 5 far into the mountain.

The first stage in this development was to take the internal roadway down from Kimberley No. 6 onto the Kimberley No. 5 horizon. Then, having gained access to the old Kimberley No. 5 rail tunnel, Joe enlarged the dimensions and followed the line of the old tunnel until the end was reached. He then continued onwards and, within a very short distance, his 'drive' entered an area of high quality and consistent slate rock, which is still the main source of raw material today.

Consideration was also given to developing to a much greater extent the light grey-green slate that is present in abundance in the Honister Mine, but difficult to access. Since 1997 only a relatively small amount of this slate has been mined and brought down from the Crag to the processing site at the Hause.

Attempts have been made in the past to access this attractive slate. In 1983, the mine owner at that time, Bernard Moore, planned to drive an access tunnel from his workings in the Kimberley Mine directly into the Honister Mine.

Later, McAlpines had also been extremely keen to work this slate band and had spent some time carrying out exploratory core-drilling into the band from the surface of Fleetwith with the intention of working the grey-green slate by open-cast techniques.

During the winter of 2014 a project to survey a possible route of a tunnel to link the two mines was carried out with assistance of experienced mine surveyors. The tunnel would connect the Kimberley Mine directly to the Honister Mine, allowing slate clog from the Honister Mine to be brought along the tunnel to the Kimberley Mine and exit from Kimberley via the usual route. It would then be transported down the mine road to the Hause. At the time of writing this project has not yet been started.

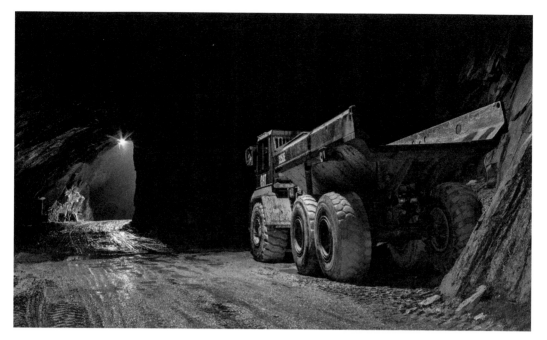

Kimberley No. 6 level is the route into the mine. The large CAT truck, normally used to carry waste rock from the mine up to the crusher, is parked in No. 6 when not required.

New heavy transport was also required and obtained during this period. The old Terrex truck had reached the end of its useful life and was replaced. More manoeuvrable 'front loaders' were also obtained and became the preferred means to transport slate clog out of the mine and down the mine road to the saws at the Hause.

New plant was not just confined to the mine. Down in the saw shed at the Hause the older of the two large stone saws was finally removed and replaced as it was considered to have come to the end of its useful life. However, others had different ideas! Although it had been in use at Honister for about eighty years, it wasn't scrapped. An enquiry from a company producing sawn stone flags led to the old saw being purchased by them and transferred to their plant in Yorkshire, where it was re-installed. It is no doubt still in use there.

The replacement saw arrived and was installed in December 2016. The mode of operation of the new saw can be pre-set to enable the saw to cut slate blocks automatically without the need for an operator to be constantly present. New polishing and sand-blasting equipment was also installed. Clearly the processing side of Honister Slate Mine's operation was being significantly upgraded and improved to allow greater output without reducing the quality of the finished product.

The daily operation of the mine is dictated by the stock of slate clog held at the saw shed down at the Hause; when stock falls to a low level, plans are then made to carry out a drill and blast operation in the Kimberley Mine. The team that work within the mine ensure that the working face is always available for further production of slate clog when required.

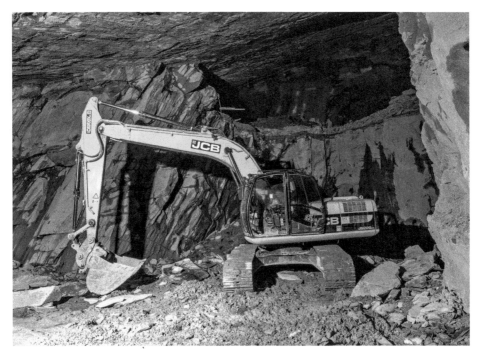

Down in the working mine, an essential piece of plant is the machine that clears rubbish from the mining areas and transfers it to the large CAT truck in preparation for transferring the waste to the crusher sited at Hopper Quarry.

The old Anderson Grice stone saw is finally removed from the saw shed on 25 October 2016. Instead of being scrapped it saw further use at the premises of a manufacturer of stone flags.

The new saw arrived at Honister on 13 November 2016. It was transported from the manufacturers in Italy directly to Honister by road vehicle. The vehicle ascended Honister Pass in the early hours of the morning to avoid traffic issues. (Honister Slate Mine)

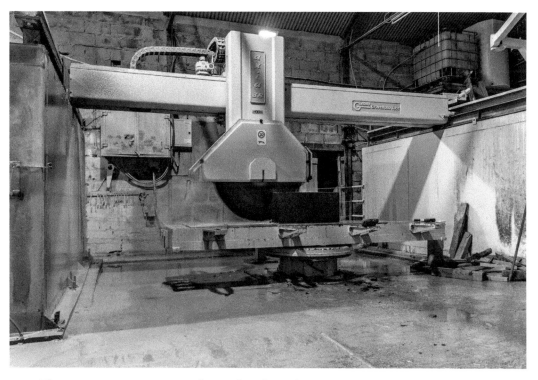

The new saw in operation, producing slate floor tiles.

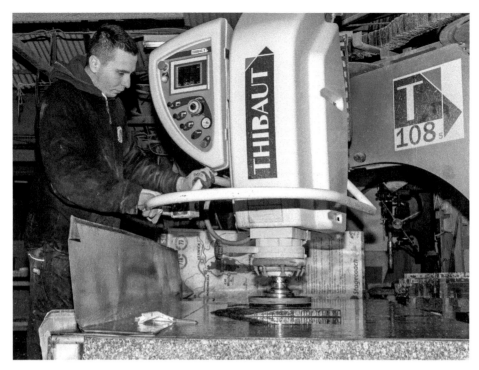

New sanding equipment in use.

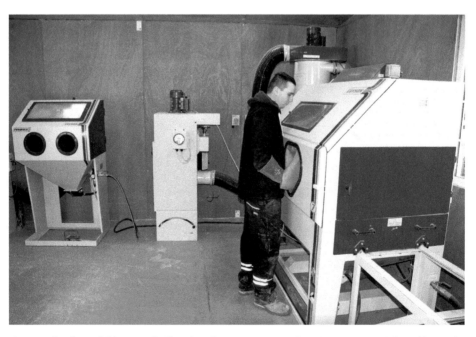

A specialised sand-blasting facility has been set up at the Honister site. This allows the surface of slate to be embossed with text, emblems and designs.

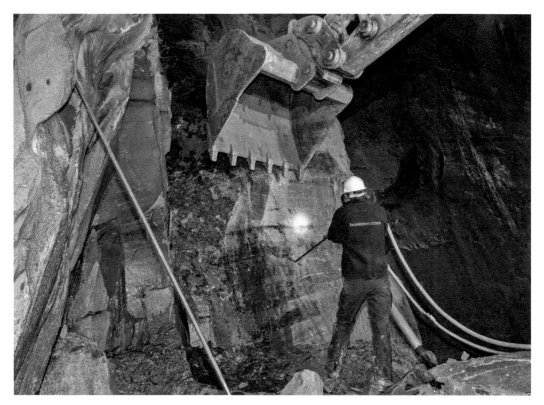

The first stage in obtaining slate block from the face in the mine is to drill shot holes to take explosives. At Honister this is frequently done by hand, requiring a skilled and well-trained operator.

A number of methods are available to drill the face, including hand drilling, using the drilling assembly and also making use of the wire saw. Once the holes are drilled explosives are then introduced into the holes and fuses are inserted. The team then clears the mine. It is normally arranged for a blast to take place at the end of the day to allow the air to clear overnight.

The following morning the team returns to the area of the blast to assess the results. If all is satisfactory a start is made to clear the slate clog that has been produced and any material that is required immediately is transported out of the mine and down the mine road to the Hause.

As both the manufacturing side of the business and the tourist side continue to develop, Honister Slate Mine has become a strong, well-established operation. It is commendable that all aspects of the Company's business are still operated from the offices at the head of Honister Pass and close to the mine itself. As the work force increases, so the younger family members have started to become more involved in the work of the Company, when school and university commitments allow. There is every likelihood that the next generation of the family will eventually take over the operation and guide it with care and skill through future decades of the twenty-first century.

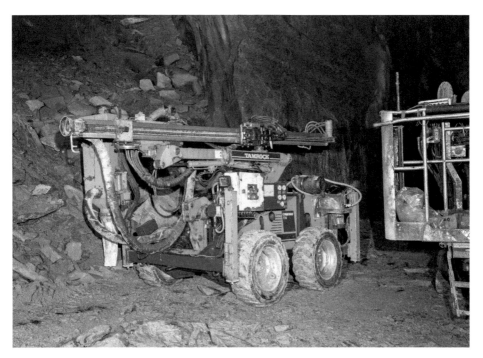

An alternative method of drilling in more accessible parts of the mine is with the use of a drilling assembly.

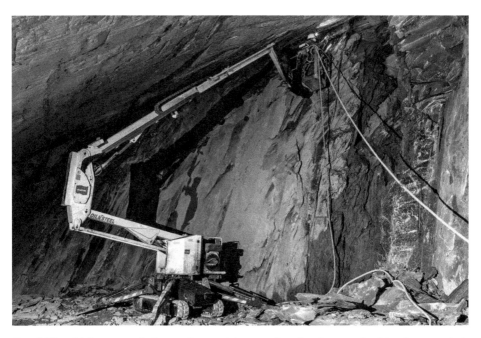

For drilling high on a rock face a cherry picker can be of assistance. In this photograph, it is being used to help drill beneath the sill in the Kimberley Mine.

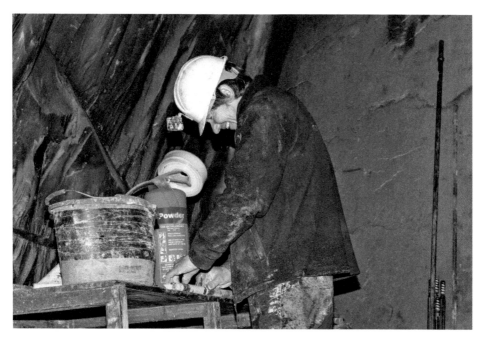

The explosive mixture is carefully prepared and filled into plastic tubing.

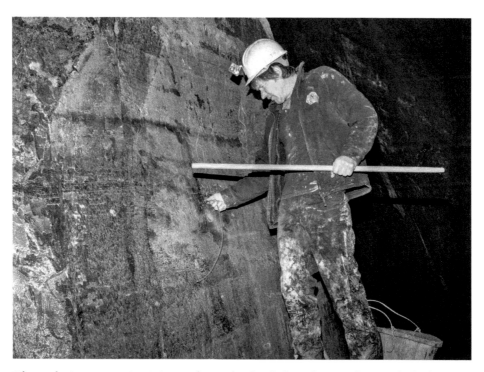

The explosive preparation is inserted into the shot hole with care, along with the fuse. It is then 'stemmed' (compacted) with a wooden rod.

Results of the blast.

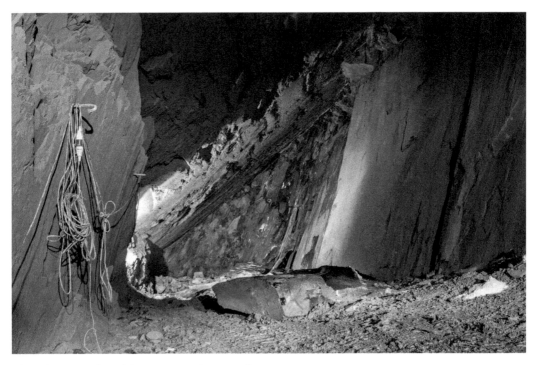

Slate clogs are selected for transport down to the mine.

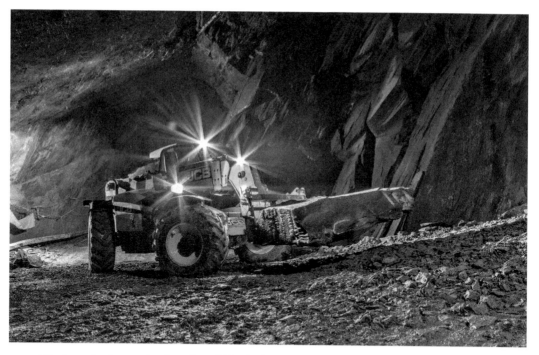

The front loader carries the selected blocks from the area of the working face up to the exit from the mine.

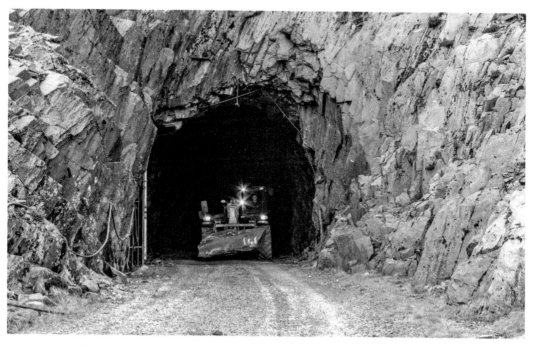

Leaving the mine.

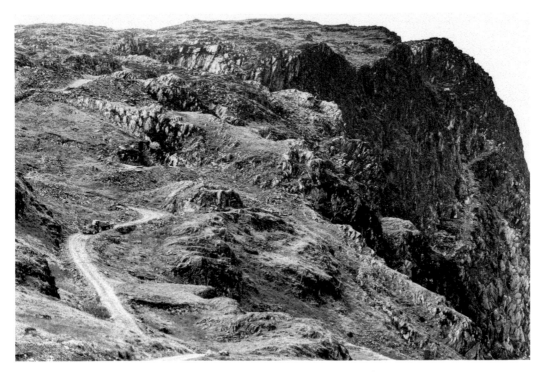

The blocks are transported with care down the steep mine road by trailer.

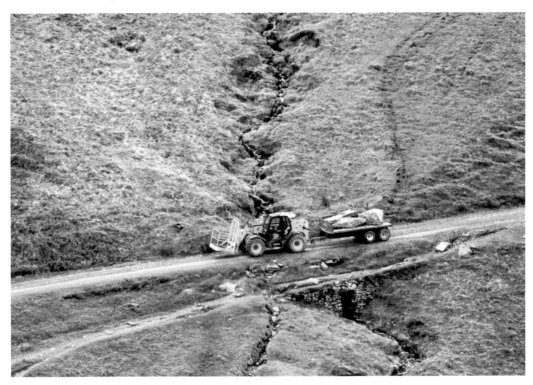

Blocks are removed from the trailer at the Hause and stored ready for use.

Broadening the Tale

Climb in the Mine

Recently a number of major developments benefitting visiting groups have been designed and installed. Many mountaineers who venture to Northern Scotland and, in particular, the Northern Isles, will be familiar with the sport of subterranean climbing that takes place in the darkness of sea caves. This can provide those taking part with a lot of excitement, but there is a significant risk of being washed off the climbing routes by a heavy swell of seawater. Those involved in the development of the sports facilities at Honister realised that part of the lower section of the Honister Mine within Honister Crag might be ideal for developing a subterranean climbing course to equal those in the Northern Isles, but without the dangers normally encountered in sea caves.

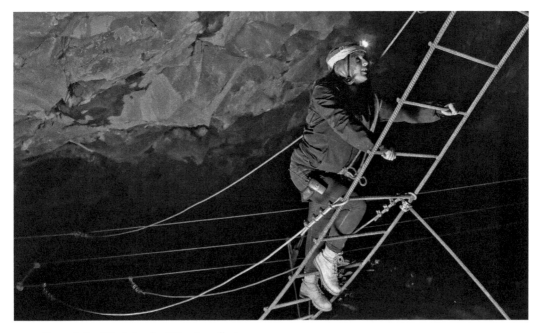

Part of the Climb in the Mine installation.

Honister was fortunate that a major international developer of climbing walls and associated equipment is based in the Keswick area. King Kong Ltd, who had already been involved in the installation of the Via Ferrata equipment on the face of the Crag, took up the challenge and Honister's subterranean climb, known as Climb in the Mine, has now become one of the most popular facilities of its type in the region.

Interactive Mine Tour

The other development involved the specialist installer of sound and light facilities to create an interactive mine tour. Piranha Creative Ltd has been responsible for installing equipment in venues such as show caves and mines throughout the UK and has been contracted to install such a system in the lower part of the Kimberley Mine, safely away from the important working areas of the mine.

There are several other locations in Britain where similar facilities have been installed by these specialists. They include the Llechwedd Slate Quarry in Wales and Cheddar Caves in Somerset.

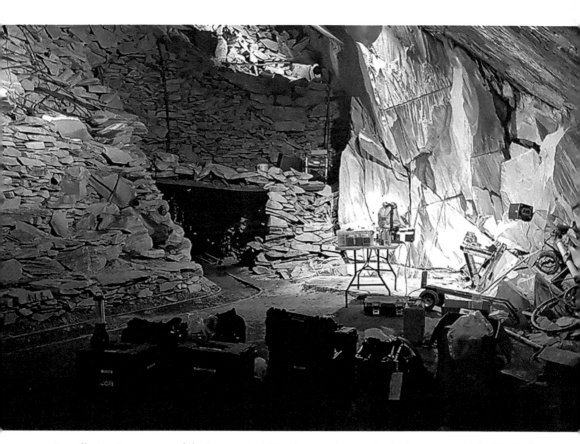

Installation in progress of the Interactive Mine Tour equipment in the lower part of the Kimberley Mine.

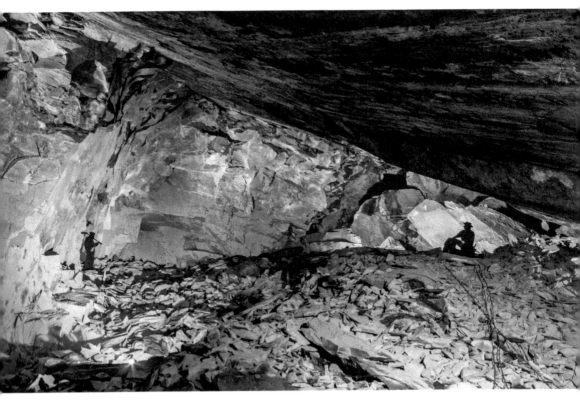

Construction of Interactive Mine Tour near completion.

Vintage Sports Car Club at Honister

There has been a long association between the Vintage Sports Car Club and Honister, spanning, in total, almost fifty years. The first Vintage Sports Car event, known as the Lakeland Trial (formerly the Northern Trial), took place in 1968. It was founded by a Frazer Nash racer, Dick Smith, and was a huge success from day one. However, in 1969 Dick found himself in conversation with two members of the local Mountain Rescue team who were also members of the Vintage Sports Car Club. Over a pint in a pub in Keswick they proclaimed they knew of a hill climb to beat all hill climbs!

The next day Dick went up to Honister and walked up the mine road, full of excitement and fear at the prospect of racing up it. By the time he reached the top he had realised it could become the best trial hill climb in the country.

The first year the trial was run was an outstanding success. But the following year not all went to plan. Dick had decided to include far more sections into the following year's trial. This meant that there were only half the number of marshalls on the sections and because of this the trial ran amazingly late. By the time the drivers reached the 'Drum House' section, a blizzard was raging and darkness was falling. Cars were only allowed up with working headlights and this led to a variety of lighting systems, including passengers holding torches, such was the keenness to race the hill. Cockermouth

Venture to Honister on a Sunday in early November and you may find something a little different occurring as scores of old motorcars roll up in the car park and take their places, ready to race up what is referred to by them as the 'Drum House' track. This is part of an annual event of the Vintage Sports Car Club. The section at Honister is the one where public access is allowed, although strictly controlled by marshals throughout the route. Walk in front of a car about to set off and you will know about it!

Mountain Rescue Team was present and played a huge part in ensuring the event ran as smoothly as it could. Out of eighty-six contestants only six made it to the top.

Since then the trial has been a huge success. Men and women from all over the world have competed in it. It continued on with the blessing of Mark Weir after he bought the mine, as he could see the potential for it. It also provided some income as the Vintage Sports Car Club paid to use the track.

Dick, and subsequently his sons, took on the role of Clerk of the Course over a span of forty-four years. In 1982 Dick borrowed a car while a friend took over the Clerk's role. This allowed him and his wife Rosemary to tackle the climb. Dick, being a racing driver, attacked the climb far too fast, but they managed to keep going as far as the last hairpin.

The year 2013 was another momentous year for the Lakeland Trial when the first lady captain of the Frazer Nash Car Club, Louise Bunting, completed the Drum House and went on to win the Trial outright, the first woman to do so.

The year 2018 is the 50th anniversary of the Lakeland Trial and 2019 is the 50th anniversary of the Drum House route. These and future dates are excellent opportunities to witness this spectacular event against the backdrop of the Lakeland Fells and historic Honister.

Dick Smith's background was as a racing driver. He had never done a trial at that time so he called on a friend, Harry Spence, who subsequently came over from Yorkshire with his trial car; his first reaction apparently contained expletives. So they took the Lea Francis trial car up it – flat out, the only way to attack – and only just made it to the top. After that the route had to be included in the event. In November 1969 the Drum House was run for the first time.

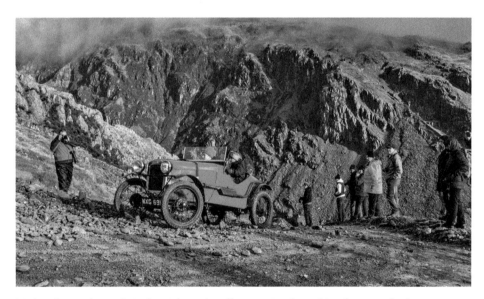

Today the track is relatively wide and well maintained, as this photograph shows, as it is the route normally used by large mine vehicles. But it was very different back in 1969; then it was only half the width with no boulders to protect drivers from the colossal drops. The inside of the hairpin bends were 1 in 2.5 and the track was much rougher, with cobbles all over the road. You were either brave to attempt it, or totally crazy. However, word had obviously got round about the Drum House route because in November 1969 there were eighty-six entries, almost double of those in the first year.

An Alvis, driven by Mike Hurst, ascends the hill in approximately 1969. (Vintage Sports Car Club)

A Vernon Derby driven by Anthony Costigan in 1972. (Vintage Sports Car Club)

This bridge just below the summit of Honister Pass was constructed in 1933 to carry a tramway over the road. The tramway linked the slate workings at Yew Crag, on the opposite side of the Pass, with the mine workshops at the Hause. Slate blocks from mines within the Kimberley slate band were brought down the steep slopes of Yew Crag by a powered incline and were then transported over the bridge to the workshops by an electric locomotive. The bridge was dismantled in the 1960s, when the Yew Crag mine closed. (Honister Slate Mine)

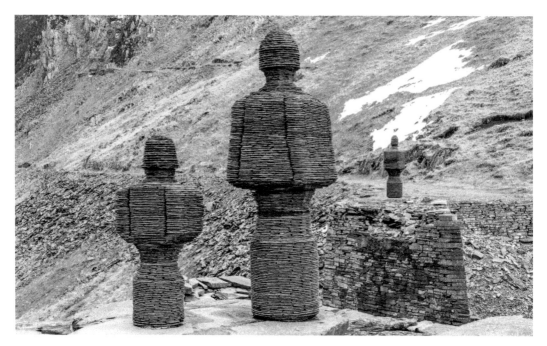

A significant art installation was inaugurated at the Honister Slate Mine in September 2017 when the final sculpture of a set of three was put in place. The three figures, known as 'hammerhead statues,' had been designed and produced by the sculptor Terry Hawkins from Loving Slate. The installation was timed to coincide with the start of a local visual art and design festival that takes place across Cumbria every year.

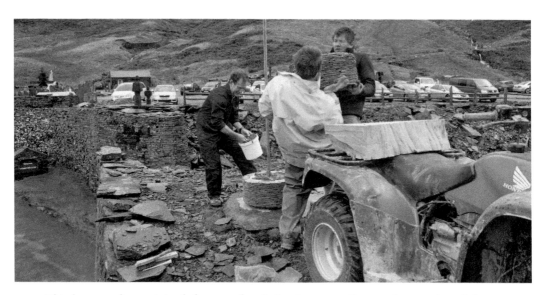

This latest sculpture joined the two already in place, standing on the remains of the masonry bridge supports at the summit of the Pass. On one side are the mother and child and on the other is the father. (Honister Slate Mine)

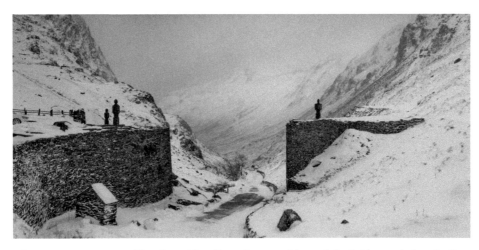

Their position, separated by the void, reflects the actual loss of the bridge and also the lives lost and families affected by accidents during many centuries of slate mining at Honister. However, the ball hammerhead design represents the strength and resilience of the slate mining community in the face of tragedy and is based on a traditional tool used in past centuries by many slate workers.

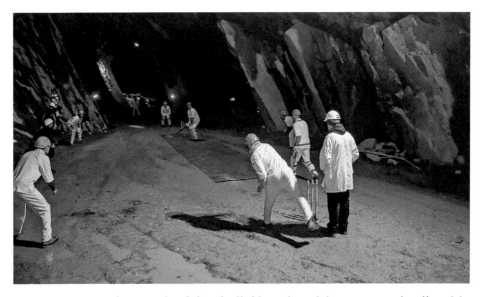

During June 2012 the grounds of the Threlkeld Cricket Club were seriously affected by flooding caused by heavy rain, coupled with poor maintenance of highway culverts in the locality. The club quickly, and commendably, embarked on a fundraising exercise of major proportions. One of the features was to play a charitable game of cricket in as many unusual locations as they could, one of which was an underground match against Caldbeck Cricket Club within the Kimberley Mine at Honister. The match took place in December of the following year and was won by the Caldbeck Club. Exactly two years after the flooding occurred the club was able to return to their ground for matches, but it took a further year before the local authority settled a payment for the cost of the damage. (Stuart Holmes)

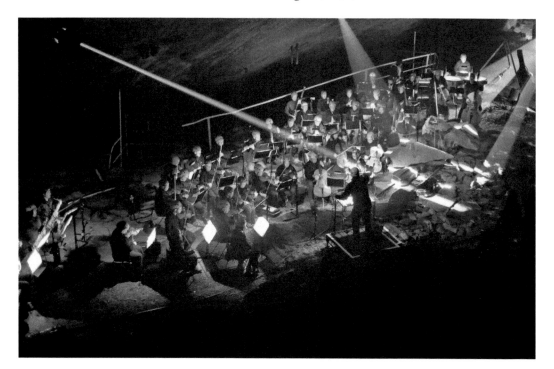

During the autumn of 2015 a classical music concert was held in a disused closehead in the Kimberley Mine within Honister Crag. The concert was performed by the sixty-piece Cobweb Orchestra. A light sculpture designed and installed by Steve Messam was created for the concert. All tickets for the event were sold within a few hours of the performance being announced. A certain degree of planning was required to get all the equipment, orchestra and audience up to the entrance to the mine. The performance was thoroughly enjoyed by the audience and several of the performers commented that the acoustics were so perfect that they felt it was one of the finest locations they had played in. (Adam Hocking)

The newly opened gallery at Honister, a retail outlet selling an extensive selection of slate products and other tourist items.

Postscript

So what does the future hold for Honister? Will the good times remain or will difficulties and complications lie ahead? As a production site, it is the envy of many involved in the industry of producing decorative and building stone. The workshops are well equipped and the local workforce is very stable, well established and well led. The mine is well operated and there are many decades more of volcanic slate remaining to be won from the Kimberley vein and with the Honister vein also taken into consideration, this could run to centuries.

The Honister Slate Mine Ltd, from its outset in 1998, realised that slate working at Honister must remain a relatively small-scale operation. The working of slate entirely underground, with waste rock being disposed of as aggregate, means that the environmental impact is extremely low. There was no room here for the grandiose schemes of the past, of open-cast 'super quarries', which, in just a few decades, would have changed the shape of Fleetwith completely.

There is also much indirect value of the Company to local authorities and communities in the area. In an age when leading industrialists are becoming more and more concerned about single-industry regions (often referred to as 'the Port Talbot Condition'), many feel that a balance is required in this district to prevent tourism becoming the sole industry. After all, who wants to go for a holiday to an area where all working people are solely involved in making money out of visitors?

First and foremost, Honister is a manufacturing site, mining a product that cannot be obtained anywhere else and maintaining centuries old traditions of craftsmanship and skill which is of enormous heritage value, while providing permanent jobs with good wages and, separate to all this, providing a world-class facility for visitors both young and old to study and enjoy.

But the main attraction of the Honister Slate Mine stems from the fact that the concept was established by one local Borrowdale lad who happened to have the uncanny and totally unique ability of 'seeing through the fog'. He had a vision of what Honister could be and how it could be established. It would be based on hard work, Lake District common sense and enterprise.

There are risks ahead for Honister but they are not connected with the resource of slate rock in the mine running out, or a falling demand for manufactured slate products. Rather, there are much more sinister and unnecessary risks; for example, an over-interference from those to whom, in the past, an active and successful traditional

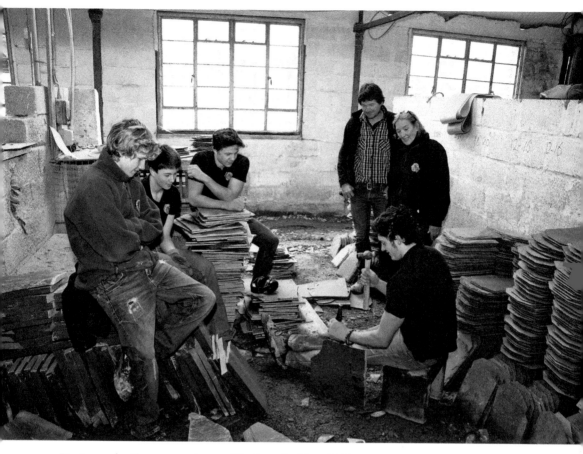

During a family get-together at Honister in May 2014, an impromptu competition of slate production techniques took place. Connor Weir is giving a demonstration on how to rive a piece of Honister slate, watched by Prentice, Tiger and Piers Weir and also Connor's father, Joe, and grandmother, Celia. There is no doubt that successive generations of the family will maintain and expand slate mining at Honister into the future. (Honister Slate Mine)

Lake District slate mining enterprise appeared to be viewed as an alien concept. An even more serious risk could arise from the Lake District obtaining accolades which might, very effectively, curtail the future operation of a traditional Lakeland industry in its present form.

Hopefully these risks will not materialise, and long may this magnificent site, with great people, a great and unique product and a great source of interest to visitors, keep operating and expanding.

Acknowledgements

The number of people who have helped with the drafting and publication of *Honister Slate Mine* is enormous. It is not possible to name them all but the two authors are extremely grateful for their assistance and encouragement.

However, they would particularly like to thank the team at the Honister Mine for their help and support, and, in addition, past employees of the Company, families local to the area and also the great many people involved in the slate industry in general in Cumbria. Many of the guides associated with the Via Ferrata routes on Honister Crag have also been pleased to help when asked.

One of the authors is also grateful for the help and information provided by Dick Smith, a senior member of the Vintage Car Club, on the history of the annual vintage car rally held on Honister's mine road. Useful information has also been obtained from Robert Wilkinson, tenant farmer at Gatesgarth Farm and Honister's neighbour. Robert's family originates from Coniston and is known to both authors.

There are many more who we have not mentioned.

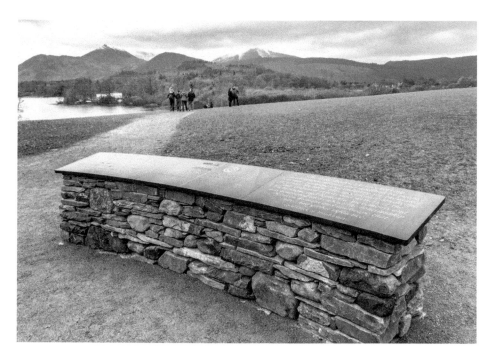

In 2017 it was announced by UNESCO that the application for the inscription of the English Lake District onto the World Heritage List had been successful. During March 2018 His Royal Highness Prince Charles confirmed the inscription by unveiling a plaque in Crow Park, Keswick, to mark the 'opening' of the Lake District as a World Heritage Site.

The plaque was produced from slate taken from the Kimberley Mine within Honister Crag and the inscription of the motif and text was carried out in the Honister workshops. The left-hand panel of the plaque gives details of the opening occasion.

About the Authors

Liz Withey is a landscape photographer with immense experience in capturing the industrial landscapes of mountain areas, such as the Lake District. Liz has lived and worked in the surrounding area for many years and has co-authored books and other publications on this subject and on mountain landscapes in general.

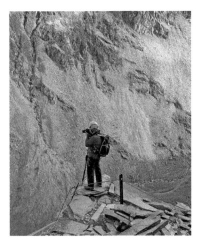

Alastair Cameron has written extensively about the industrial history of the Lake District mountains. He was born and brought up in the old mining village of Coniston and, in the photograph above, is being filmed for an edition of *Countryfile* describing slate working at Honister.